"God makes us brave. When we face the pain of irreplaceable loss, He carries us to the shores of a new horizon. As Rhonda learned to praise God through the devastatingly tragic car accident that claimed the life of her son, Dan, she began her healing journey with God. If you have experienced pain or loss in your life, *FreeFall: Holding onto Faith When the Unthinkable Strikes* will set your feet on solid ground. Author Rhonda Robinson writes with authentic grace that will enable you to embrace the new normal of a new beginning in your life. God is using even the loss in your life to create a masterpiece of purpose."

**—Sue Detweiler,
best-selling author of *Women Who Move
Mountains: Praying with Confidence, Boldness,
and Grace* and pastor of Life Bridge Church**

"Raw. Beautiful. Encouraging. Hope-filled. Through true stories of real people who have battled grief and found surprising victories in the process, *FreeFall* offers a light to anyone who feels stuck in a dark pit."

**—Anita Agers-Brooks,
international speaker and award-winning
author of *Getting Through What You Can't Get Over***

"Rhonda is a talented woman and writer, and she is brave beyond words, as you will see in the pages of this book. Over the years our readers loved her wise and heartfelt articles on life and family and her encouragement to endure through whatever life throws at you with faith. She has been an inspiration to me personally, and I know she will be to you as well, as you read this incredible book, *FreeFall*, born out of experiential knowledge."

**—Sharon Hughes,
radio host and founder,
The Center for Changing Worldviews**

"Drawing from her own journey out of dark despair, Rhonda Robinson brings a roadmap for others in *FreeFall*. She has experienced what God Himself designed as the greatest sacrifice: the loss of a child. This book serves to shine a light out of the dark place of grief to a next step, to another safe step and then one more, until you find, like Rhonda did, that you have come out."

<div align="right">

**—Angie Penrod, MEd,**
**wife of Guy Penrod/Grammy and**
**Dove award-winning gospel singer, mother of eight**

</div>

"*FreeFall* is a powerful healing journey as Rhonda Robinson tours her readers through the impact of death ripping her heart and soul into many pieces to the transforming power of God's mercy, beauty, love, and truth. Rhonda Robinson's gift of writing breathes new life as she guides her readers out of the dark hell of loss and brokenness and courageously explores the caves of despair. She brings secret treasures of healing that only can be found in the deep hidden places of God's love and mystery. She wields her pen like an artist's brush and maneuvers the reader through the birth pangs of new discoveries that often go unexplored because of the limitations of human understandings about death. God brought Rhonda a revelation that all people need to hear, especially those who are in the mighty grip of grief. She has pilgrimaged through the shadow of the valley of death and has come out the other side with nuggets of gold and jewels that hold refreshing health and healing. I would recommend for all my clients to read this inspiring walk of faith. He can heal the deepest, darkest, loneliest pain that exist, and through the suffering of loss, as hard as it is to believe, there is treasure."

<div align="right">

**—Kathleen A. Stommel, MA,**
**Christina Counsel Associates**

</div>

# FreeFall

## HOLDING ONTO FAITH WHEN THE UNTHINKABLE STRIKES

### RHONDA ROBINSON

**NEW HOPE®**
PUBLISHERS
Imprint of Iron Stream Media

Birmingham, Alabama

New Hope® Publishers
100 Missionary Ridge
Birmingham, AL 35242
NewHopePublishers.com
An imprint of Iron Stream Media
IronStreamMedia.com

Library of Congress Cataloging-in-Publication Data

Names: Robinson, Rhonda, 1959- author.
Title: Freefall : holding onto faith when the unthinkable strikes / Rhonda Robinson. Description: Birmingham : New Hope Publishers, 2020.
Identifiers: LCCN 2019030805 (print) | LCCN 2019030806 (ebook) |
    ISBN 9781563093005 (trade paperback) | ISBN 9781563093036 (epub)
Subjects: LCSH: Christian women—Religious life. | Change (Psychology)—
    Religious aspects--Christianity. | Consolation.
Classification: LCC BV4527 .R5856 2020 (print) | LCC BV4527 (ebook) |
    DDC 248.8/6--dc23
LC record available at https://lccn.loc.gov/2019030805
LC ebook record available at https://lccn.loc.gov/2019030806

ISBN-13: 978-1-56309-300-5
Ebook ISBN: 978-1-56309-303-6

1 2 3 4 5—23 22 21 20 19

In memory of Elijah Daniel Robinson.

With your birth I dreamed that one day you would become a mighty man of God with the faith to walk into the lion's den. With your death I fell into the lion's den and found the Father's hand to lead me out.

To all the parents with child-sized holes in their hearts.

# Contents

# Acknowledgments

Because of so many who walked this path with me, this book exists. Not as just my story but as a witness of hope. From my church family who walked beside me through the darkest times to those who saw beauty within the ashes and urged me to put it into words for you to hold.

Thank you, Jami. My rainbow baby, my firstborn daughter. When we lost our Danny and I shut down, you stepped up—put your own grief on hold to tend to your mama. You wrapped me in your prayers of protection and walked alongside me down the hard roads. You will see much of the fruit that has come from our conversations within these pages. You have always been by my side, feeding me truth when I couldn't feed myself.

I am also grateful for my youngest daughter, Emily. You were left alone to finish growing up in the ashes of your parents' grief, without your best friend. Much of this book was written with you sleeping in the next room. You were our reason to face another day.

My children, Chris, Sarah, Kelly, Chelsea, Hannah, and Tom, thank you for always believing in me and allowing me to freely share your lives through my writing over the years and especially in this book. You have never held back in your love—for me or for each other.

Thank you, Jeanne, Lolly, Gerry, Josie, and Kat, for allowing me to share your stories of heartache, truth, and triumph. And my special

thanks to the late Bob Henningsen, whose faith, perseverance, and legacy left an indelible mark on my family.

To the entire Iron Stream Media team, you have my deepest gratitude. I am so thankful for your prayers and your excellence. I am humbled just working with you and marvel at how you have put life into this book.

Saving the best for last, I must thank my husband Mike. My story is our story. Thank you for being by my side. Not only through the all the sorrow we have faced together but in writing this book. This book would not be possible without the love and support you have given me through the years it has taken to birth. In your arms I have flourished.

# When the Unthinkable Transforms Reality

The cold metal of the operating table was hard and unyielding. The physician walked in unannounced. Without warning or anesthesia, he began his work. The searing pain of the first cut caused my chest to heave a deep gasp. The inhuman sound of a low, guttural moan hung in the air. As the knife plunged still deeper into my chest, I began to realize the voice was my own. The agony surpassed what my mind could grasp. My head began rocking uncontrollably back and forth as disbelief overwhelmed me. Only one word escaped: "No." An inner voice tried to push despair away by whispering, "This can't be happening to me."

Then, once again, the knife of reality plunged deeper. The surgeon reached in, cupped my beating heart in his hands and placed it on my chest. As the fog of pain rolled in, my mind became clouded. My thoughts raced in slow motion. Truth became a chilling mist of numbness that fell over my soul. Nothing was real anymore—only the agony of the raw, gaping wound in my chest and the weight of my heart beside it.

"He died at the scene" were the words that pierced me like a surgeon's knife. As my mind tried to grasp the reality of the unthinkable, the pain reached past the marrow and into the inner essence of my being.

Though searing, my pain and tragedy are not unique. There are many words that, in an instant, can sever you from your life as you knew it and plunge you into a world you never thought you would enter—"It's malignant," "I don't love you anymore; I want a divorce," "We can't find a heartbeat." Few of us escape this life without the shattering effects of the world we live in.

While the wounds these words create are invisible to the people around you, the pain is life-threatening. What you may not yet know is whether or not you will survive the despair or how to face tomorrow, let alone the future.

There is no way for me to know the depth of your loss or the mountain you're facing. What I do know is the pain of losing. I know all too well what it's like to completely shut down under the weight of grief's sorrow. I know what it is like to pick up the razor-edged shards of a broken life. What we hold in common is that we have both faced the unthinkable. The fact you reached out and opened this book is evidence that your soul wants to join life again, but your mind can't grasp how that is possible.

You can.

You will.

It's my prayer that as you turn these pages you will feel the hand of God and hear His whisper—even in midst of the loudest storm of your life. As you walk with me through these pages, I will give to you what was given to me—pieces of truth that shine a light in the darkest hours and recipes to heal the unseen, gaping hole in your chest. Time doesn't heal all wounds, but we have a Heavenly Father who does. He is the Great Physician who closes our wounds and wipes away our tears.

You will survive.

Your heart will be put back in place by the hand of God—not just restored but infused with his peace and strength.

## Chapter 1

# When the Storm Strikes the Nest Falls

The rhythms of our lives, the church activities, and the simple daily routines of family life painted a fence of false security around us. Life was wonderfully chaotic and predictable in the way only a house packed with children can bring. We were at the tail end of raising our brood of nine in a century-old farmhouse surrounded by cornfields. My husband was a police officer turned private investigator, and I filled my days with laundry, homeschooling, and chasing muddy paws out the back door.

From dusk to goodnights, our days would end in some variation of the same scenario. Every evening, just as the sun began to sink into the flat horizon line of central Illinois, we could hear the distant roar of Jamie Henderson's old truck coming to feed the small menagerie she boarded with us.

For my two youngest children, Emily and Daniel, the sound of her motor lit up their faces like the musical beckoning of an ice cream truck. The distant puttering was their three-minute-warning to race the oncoming vehicle into the barn and find a new place to hide. These two were notorious for crawling inside grain barrels, slipping into the darkest corners, and hanging in the rafters like bats.

Jamie was always mindful of children or critters playing in the yard. From inside the house, I could hear her tires slowly rolling onto the gravel driveway. From that moment on, the successions of sounds were almost always the same: the shutting down of the motor and the slam of a door. Then came the brief pause of silence . . . sliced wide open by a sharp scream that filled the country air. The scare team would then stumble their way back into the house, doubled over with laughter. They would take turns recounting their every strategic move and reenacting her expression as they tried to catch their breath.

From the outside looking in, our family must have looked like a homeschooling version of a 1980s sitcom with an old house full of children of all ages. As the older ones began to marry and leave our nest, they added a steady stream of grandchildren. As is common in large families, our children paired up in buddies—everyone had their own built-in best friend. Emily, the caboose of our family, had two—her brothers Tom and Dan. Incoming grandchildren had readymade playmates. While the farmers planted in the fields around us, we raised crops of children in that old house.

I can only guess that it started out as a joke—the children mimicking the ending of *The Waltons*. In case you are too young to remember the series, every episode ended with the family members calling out to one another, "Goodnight." It was sweet and touching— an endearing display of the love they had for one another at the end of the day. Of course in our Robinsons' version, it was one-part ploy, one-part affection, and two-parts sarcasm. Although, like the Walton family, each night would end the same. The "goodnights" would crisscross throughout the upstairs and in and out of the bedrooms, loud enough to penetrate the old plaster walls.

After all the giggles and goodnight wishes, Hannah would call out to her younger brother Dan, "You forgot to kiss me goodnight." With a quick apology, he would spring out of bed and rush into

his big sister's room to kiss her cheek. Like clockwork, with Dan just two footsteps past the door and into the hall, Hannah would say, "Oh, Danny, would you mind turning off the light?" Without hesitation or the tiniest hint of suspicion, he would give a quick "Oh sure," and take the steps back to flip the light switch. All while his sister hid her, *he-fell-for-it-again* giggle under her blanket.

The last summer we lived in that house, we were planning our daughter, Hannah's, garden wedding for the coming August. At the same time, she was preparing to face reconstructive surgery on her upper thigh from a childhood injury. The morning of the surgery, Dan, who was just about a month away from his fourteenth birthday, begged to go with us to the hospital. All I could think of was how difficult it would be to keep this teenage boy entertained and how much it would cost to feed him out of vending machines all day. My answer to him nonetheless was truthful. "No. You will have much more fun here with the kids. You will be bored out of your mind sitting in a hospital waiting room all day." With the mom-door closed, he approached his dad—yet the answer remained the same.

In the midst of saying our goodbyes, Dan asked if we could gather to pray as a family for Hannah. I hardly remember the prayer. As I lowered my head, my mind raced out the door before me, carrying a load of worry and anxious haste. Standing in a circle with my family and holding little hands, to this day, I can only guess what we prayed.

Jami Lee, our oldest daughter, along with her husband and five young children, had just moved into our home a few months earlier. Our family was shrinking and hers was rapidly growing. Our five-bedroom, three-story house that once held the laughter and sticky fingerprints of nine children and one obese golden retriever was growing quieter with each passing wedding. We decided it was finally time to build a new home in our empty

pasture. While we began the process of turning dreams into blueprints, grandchildren replenished the sandbox and hallways with tiny giggles.

Dan did have fun that day. He spent the entire afternoon with his eight-year-old nephew Zachary. We often joked among ourselves that it was great to have Jami back home; she brought with her playmates for our Dan, a natural-born, absent-minded professor, who spent a large portion of his time loitering in the playground of his own thoughts inventing contraptions and concocting heroic stories of battlefield valor. Zachary proved to be the perfect sidekick. He was quiet and thoughtful. They spent that entire day together building an elaborate, detailed space shuttle made completely out of imagination and K'nex. Dan had a captive audience as he retold his football glory plays—all while ducking kitchen duty under the banner of being a good uncle.

As my day at the hospital wore on, I became more confident in my decision to make Dan stay home. The surgery took longer than we expected. Hannah had split a muscle when she fell at just two years of age. Over the years it had required a couple of surgeries to remove tissue that caused her a fair amount of pain. It was our hope this surgery would give her final relief before she began her new life as a married woman.

An unexpected buildup of scar tissue added several hours to the procedure. The early-morning minutes stretched into late-afternoon hours. Waiting for the news our girl was in recovery twisted the lagging time into parental anxiety. My husband Mike and I, along with Hannah's fiancée, were all tired, hungry, and a bit on edge. We wanted nothing more than to have some elderly volunteer wrapped in a pink smock invite us to go up to Hannah's room to wait for her —the sign all was well.

At last, the word came. We all began to make our way to the next floor. Just as I stepped into the elevator, my phone rang.

"Do you know where the boys are?" Scott Douglas, a pastor and close family friend, asked rather matter-of-factly. I explained we were with Hannah in the hospital—that we had been there all day, and I knew Tom had open gym basketball at a local Christian school.

Hanging up the phone, I thought Scott's interest a bit puzzling. Although our sons were close friends, they didn't play basketball together. Ours was a homeschooled student on a private school team. Scott's son went to a public school. He had sounded more confused than alarmed as he'd explained that Brian Lowry was looking for the boys. That made a bit more sense—Brian coached the boys' basketball. But why bring Scott into it?

Within the few steps it took to get from the open doors and through the entrance of Hannah's empty room, the phone rang again. This time, the caller ID read, *Brian Lowry*. When I answered, it wasn't Brian after all. It was his wife—my friend—Cristal. I barely got "hello" out before she began talking. My mind couldn't catch up with her. Apparently, my confused questions caused her to stop mid-sentence. She realized I had no idea what she was talking about. After a brief composure pause, she uttered the words that pours life into every parent's deepest fear, "Oh, Rhonda, there's been an accident—*it's bad.*"

She went on to explain one of the boys was airlifted to Carle Hospital. The other three left the scene in different ambulances. Each one was taken in a different direction. I learned later it was an on-scene decision to send each boy to a different hospital so they would not overwhelm our small towns' emergency rooms.

All I understood, all I could comprehend at that moment, was that my son, Tom, drove that day. Just a couple months before he got a truck for his sixteenth birthday. It was a gift from his older brother Chris, who at the time was a general contractor. Chris planned Tom's summer—his little brother would work for

him. I had no idea who Cristal said was in the truck with Tom. My heart, mind, along with my hearing, all but stopped at the word *airlifted*. Cristal had little information to give me and even fewer answers.

My mind and emotions swirled in a funnel cloud of questions. *Who was airlifted? Which hospital do I go to? Where is my Tommy? Is he calling for me? Was he able to keep identification on him in his gym clothes? Is he scared? Was he the one in the helicopter?*

"I have to go . . . I have to go now." I stammered blankly at the nurse. Then turning to my future son-in-law, I gripped both of his shoulders and pleaded, "Take care of my girl. Don't tell her anything about the accident. Just love her and be there for her—I can't . . . I can't . . . I have to go."

As my husband and I stepped out of the hospital, the weather betrayed us. Black and gray storm clouds tumbled across the summer sky. The prairie winds of central Illinois are particularly fierce in early June. Hail threatened the windshield as icy rocks pelted us from above. It didn't matter. Nothing mattered except finding our son. The first hospital to check was an hour away. Mike drove our truck as though it were his old police car with lights flashing and sirens screaming. I feared the windshield would shatter, and I didn't care all at the same time.

Racing the unknown, I frantically called one emergency room after another. I could hardly hear the static-ridden voices of strangers through my fears. The parents of the other boys didn't know whose son was where either. So I dispatched my adult children. Couple by couple, they went to every hospital in three rural counties. One of us would find my Tom. Everyone scattered into the storm—all searching different emergency rooms for their missing little brother.

Amid the confusion, something pushed instant replay in my mind. Slowly the volume turned up, and for the first time I actually

heard Cristal's words clearly. It was in that moment when I realized exactly who she said the four boys were: my Tom, his lifelong friends Schuyler and Sam Binion . . . and my youngest son, Dan. Wait. *Danny? He was supposed to be at home with Jami. He's in eighth grade. He's not old enough to play basketball with the high school boys.*

As we pulled onto the interstate, an unknown caller appeared on my phone screen. A soft voice on the other end identified himself as the chaplain at St. Mary's Hospital, the one we were in route to. In a slow, almost enunciating manner, he explained he was "assigned to Thomas." He described our son as responsive and urged us to come quickly.

"But where is Dan, my other son?" He had no answer. He seemed to dismiss our questions about our missing boy. His only focus and concern was Tom. We needed to come immediately, he repeated, despite my line of questioning. His voice grew firmer with each repetition.

One boy was found. Another was still missing. All my thoughts and fears shifted to my missing baby, my youngest boy—my Danny. As we pulled into the hospital parking lot, I began to cry deeply. It was as though my spirit knew something my mind couldn't grasp. From the depths of my being arose a sound I had never heard before.

By the time we made our way through the hospital doors, we were told which hospital the Binion boys had been taken to—both were in critical condition. Everyone was accounted for except our Dan. As far as I was concerned, he was now our priority. We had to find my frightened boy, who was lying in a cold hospital room without me. I couldn't bear the thought that he was hurt and alone. My mental plan: check on Tom—go back out and find Dan.

As we entered the emergency corridor the familiar faces of friends who heard about the accident lined the hallway. Tragic news travels fast in a rural farming community. Brushing past

their somber faces, we were met by the same chaplain who had summoned us by phone. He ushered my husband and I past our adult children and their spouses. Strangely, he was no longer concerned about Tom's need for us. In a low, slow, controlled tone, the man was now insisting he needed to talk to us privately before we could see our son.

We were led into a small room. Behind closed doors, two strangers doing their best to be kind gave us the news of our son Danny and said to us the most horrific words I have ever heard uttered: "Your son died at the scene."

## The First Steps into the New World

Our oldest son Chris beat us to the hospital and Tom's bedside. The first thing Tom asked him was, "How is everyone else?" Chris, knowing Tom would take full responsibility for his brother's death, told him that everyone was all right. "In fact," his big brother lied, "You took the worst of it." This news calmed Tom, as Chris knew it would. But it wasn't the truth. We would have to face that ugly reality together when everyone had the strength. Tom suffered from a severe concussion, a torn knee, and a countless amount of shattered glass embedded throughout his body.

Chris, along with my husband and I, all slept in Tom's hospital room that night. It marked the beginning of many nights and predawn hours that I would wake to the painful sounds of my husband's heart spilling sorrow onto his pillow.

Just before dawn the next morning, I went down the hospital hall. The scene as I entered the dark waiting room is forever etched in my mind. Cristal and Brian slept sitting up, using each other as pillows. Beside them were Cristal's sister Katrina and her husband Paul. And then there was Brian and Debby, who'd driven across two states in the middle of the night just to sit with us. All three couples

were draped over the stiff, unyielding metal chairs. They were all still there. Waiting, watching silently with outstretched arms for us to fall into. At the time, it seemed the whole world felt our loss and grieved with us. It was comforting.

But that didn't last.

Our closest friends gave us room to grieve—at least for the first year. However, most of our children, even the adults, needed us to be normal again almost immediately. It seemed as though everyone in our lives tried to pull us to our feet, saying, "Life goes on."

I get it. To some degree, they were right. After the accident, my heart kept on beating, air continued to fill my lungs, and the sun rose to force me from my bed and face another day. I will concede that life around us kept marching on, demanding we keep in step. But the life I once knew was gone forever. My life would never be the same. *I* would never be the same. It was as unrecognizable as the pile of twisted metal that was once my son's truck.

Do you know that feeling?

From the moment those unthinkable words were uttered, I was kicked into a world I didn't want to enter. A world without my baby boy.

From the outside looking in, two years past the death of a child or a life-shattering experience might seem like plenty of time to recover.

It's not.

In the first two years, time only taught me how to hide the pain a little better, how to cover the seeping wound in public. But healing wasn't yet within my grasp. The second anniversary of a death doesn't bring healing—it confirms the loss. The new reality is here to stay. *Two years—he's never been gone that long before. He's really not coming back.*

I had a chance meeting with a woman who had lost her ten-year-old-daughter just two years earlier. Her pain was engraved deep in

her face. The wound, where her heart once was, still seeped with sorrow too raw to hide. When a mutual friend introduced me as someone who had also lost a child, the grieving mother asked with a stern, almost accusing voice, "So tell me. Do you survive? Does your marriage survive? 'Cause it sure doesn't look like mine will."

The honest answer is *yes* and also, *no.*

In those early days, I remember thinking it was as though I were walking in slow motion. I imagined a long, narrow path winding up to the peak of a mountain. The path was treacherous and rugged with sharp rocks. To the right there was a steep drop overlooking a vast blue sea of calm water. It was cool and inviting. The wind blowing over the water whispered to my soul. It told me of the man I would never know in the boy I lost. It reminded me of his long hugs and his crystal blue eyes hiding behind long, wispy blonde bangs. It taunted me, whispering images of what might have been. It begged me to come in and wade through the thoughtful waters of *what should have been.*

## Forever Changed

This is not the path we chose; nevertheless, this is the path you and I are now on. You are not alone. Tragedy has come into our lives uninvited. In doing so, it revealed truths we couldn't see before. Not the least of which is the fact there is pain and sorrow everywhere. Whether it is the death of a marriage, child, spouse, or parent, an accident, or a life-altering event, the common denominator is grief. Everywhere you look there are hurting people. It's a strange quirk of humanity that we don't notice in others what we aren't experiencing. Once you become pregnant or miscarry, that's when you begin to notice all the baby bumps. Grief is much the same way.

Grief is a deep sorrow that brings with it a pain even modern medicine can't cure. The only way to survive is to embrace it. To fall

into its depth and reach up for the hand of a living God. It is there. Even if you can't feel it or see it through the haze of mourning or anger. That's all right. It's there to grasp at the moment you are ready to reach for it. Unseen. Yet real as the pain you feel.

We live in a culture that has not learned to value the lessons taught by sorrow, pain, and the testing of your faith. We are just a couple generations away from the gut-wrenching poverty of the depression era when children were placed in orphanages by parents who couldn't feed them. The generation that survived concentration camps where they were stripped of everything they loved and subjected to the cruelest evil man can conjure are fading away into history. By contrast, we live in prosperous times. Although that doesn't mean we are immune to unspeakable anguish. Perhaps it is because we as a society are not suffering together as generations have in times past. That lends itself to a collective feeling that life must be good all the time in order for us to live a full life. So when tragedy strikes us down, we expect one another to dust off our knees and keep going.

Mourning is no longer understood by our culture now drenched in entertainment. Unhappiness is no longer a sign of the need for course correction. Instead we are sold promises of happiness in all forms. What is hard to grasp in times of plenty is that God, like the father running beside his child with one hand on the back of the bicycle seat, is there to give you the balance and guidance you need to feel the wind in your face again. He is there to pick you up when you are face down in the dirt, tears stinging your eyes so badly you can't see the road home.

God sees your lifespan. He sees you not by your circumstances or actions but rather by the essence of your soul. In spite of what you feel at this very moment, He can still be trusted. We live in a culture that values self-reliance. We are told we are masters of our own fate. We can write our own story. We did not write this story. ✳

I did not choose to have my son ripped from my arms. You never think your life could shatter so quickly. We plan our lives for what makes us happy. We don't plan our lives for sorrow. But the God of the universe knows the depth of sorrow *and* what can be birthed out of it.

Life-altering events do not have to define who you are. Instead they can reveal the God of the universe and the depth of His love for you.

Just as new life bursts forth from the agony of childbirth, so too can a new life come through the pain of grief. A life shattered by this natural world can be refined and rebuilt by the unseen hand of God.

It is my prayer that with guidance from the Holy Spirit, this book will link our hands to walk this rugged path together into your new reality. God has given us everything we need to live a life that radiates purpose and meaning, even in the face of tragedy.

## Prayer

Heavenly Father, the path before me is hard. This is not the path I chose. I can't see where it ends. It looks dark and long. Nothing seems as it once was. My heart aches. I will only survive by the touch of Your hand. I want to rejoin life, but I don't know the way on my own; everything has changed. I want to feel Your presence. I give You my pain and my life, and I ask You to give me Your peace and Your wisdom. You are the Great Physician. You alone can put my heart back into place. I give You my heart. Take it, Lord, and make it new.

## Chapter 2

# The Cruel Master

No one ever told me that grief felt so like fear.

—C. S. Lewis, *A Grief Observed*

e didn't look anything like my Dan. He was tall and slender with brown hair. He was much older, about seventeen, I imagine. His mother was confined to a wheelchair, and his sister was already an adult. Maybe it was how he tossed his head as he flipped his long bangs from his eyes. Maybe it was the loving-kindness he so easily showed his mother. Maybe it was the way he smiled when he made his sister laugh that caught my eye. The three of them were loading their groceries onto the belt while making bets on the final tally. I stood alone behind them. Waiting patiently. Watching. Then it hit without warning.

A wave of grief crashed over me. The weight in my chest was crushing. Sobs began to swell in my throat. *Oh God, oh God, I'm going to lose it. Please don't let me lose it. Please. Please . . .*

A dreadful scene played out in my head: I saw myself dropping to the floor crying uncontrollably. Then an alarmed clerk would have to leave her line to attend to this pathetic blubbering woman blocking her aisle. A concerned crowd of onlookers would gather around.

"What's wrong, dear?" they would ask. Then I would have to spit out the words caught in my throat. *"He's dead." "*Who should we call?" They would ask.

Then they would have to figure out what to do with me. Call an ambulance? Call my husband? How would they fix it? They would have to do something to scrape this broken woman off their shiny floor. After all, they have lives to get on with.

*"It's been two years,"* I would then have to confess.

*Please, God, please don't let me lose it. Just get me out to the car. Just get me somewhere I can cry without making a spectacle of myself.* Over and over I prayed, *"Please, just get me to the car. Just get me to the car."* It took everything I had to not become a puddle on the ground. Thoughts of what a horrible scene it would create if I let so much as one tear loose sealed my lips airtight. I couldn't breathe. I was afraid to. So I held my breath—terrified of drowning in my own sorrow in the middle of a superstore.

Grief sneaks up behind you and knocks you to your knees when you least expect it. You wake up with it sitting on your chest as it tries to smother you just before the sun comes up. The lifespan of grief is the opposite of birth. One is the wrenching of the body, the other is the wrenching of the soul.

My daughter pointed out how similar the processes are. Birthing begins with pains that warn the time is near. When the pains begin, at first they are far apart. Sometimes so far apart you have time to forget the severity of it until the next one comes. As they increase, the pain is harder to bear. The contractions become closer together until the pain is so intense you feel your very survival is at stake. Then life begins. Your life is forever changed. Death is this same process in complete reverse. Life ends. Your life is forever changed.

There is no pain suffered on a daily basis that is equal to the pain of grief. Grief comes in waves. It sweeps over you. But you

don't have to fear it or pretend it isn't there. It is okay to feel its pain.

People often question, if God is a good God, then why is there so much pain in the world? Why would He allow good people to suffer? If God loves me, why do I have to go through this? Perhaps we can better understand God the Father by understanding what a good parent is.

## God's Parenting Is Better than Our Own

He was a hip, young father. His hair was dark and meticulously groomed to give a casual tussled look. He wore jeans with a jacket over a T-shirt and a scarf tossed over his shoulder. His son was around five and was walking next to his dad's shopping cart. Judging by the amount of groceries in the cart, they hadn't been at it long when the boy broke away and grabbed a bag of candy off the shelf and tossed it into the basket. Dad immediately gave the boy a firm, *you-know-better* stare while reaching in to remove the new item. The boy returned a glare and went over to fetch another bag. This time the bag was thrown in the cart harder as though the force alone would make it stick this time. When his father once again returned the candy to the shelf, the boy resorted to a different tactic. He ran over to the meat counter and began throwing packages to the ground. Then the boy opened up his rapid-fire demands with an ear-piercing scream once only heard on primitive battlegrounds. With his fists clenched tight at his side and his face jetted out like a loudspeaker he shouted, "I want my SWEETIES! I want MY SWEETIES! I WANT MY SWEETIES!" The embarrassed father took a step back as every eye in the store turned to him as though to say, what's wrong with you? Of course everyone expected the father to take control of the situation and make the son behave. Apparently that was not his custom. It was then the camera panned

out and the commercial drew to a close. The final sales pitch was a voice-over with a spotlight on the humiliated father standing next to his son who is screaming, prostrate on the grocery store floor. "Don't let this happen to you—use condoms."

This humiliation, the sponsor would have us believe, was all due to the fact this poor guy had been careless enough to become a father. The situation this French commercial presented gave the false narrative that all children are little monsters, and there is no way around it other than to not have them in the first place. On a lot of levels, this is how the culture, French or American, sees children and parenting in general. But good parenting is hard work. If you're a parent, you are probably thinking as I was—this would never be tolerated. A good parent does not give their child everything and anything he or she wants.

It is not the role of a parent to entertain, pamper, and indulge every whim of their child. It isn't, although many might disagree on this point, a parent's role to make life as easy and pleasant as possible for their child. It is the role of a good parent to provide for every *need* for their child. To help him or her grow into a mature, kind, and productive member of society. One who is capable of providing for himself or herself and a family. It is about preparing for the real world. A human child is more than a bundle of wants and needs.

Sometimes it's telling them they can't have candy. Other times it means a trip to the emergency room. Any parent that goes to the emergency room with a sick baby understands the pain of doing what is best for their child—in spite of how difficult it is to watch.

When my second grandson was born, he developed pyloric stenosis, a condition that hampers proper digestion. After every feeding my grandson would projectile vomit everything he consumed. Sitting in the hospital room with my daughter as she

tried to console her infant son was one of the most heartbreaking scenes I've ever witnessed.

In direct contrast to the screaming of the spoiled boy wanting his candy was the shrill cry of this starving infant. There was fear, if not sheer terror, in his eyes as his mother couldn't feed him. For twenty-four hours his parents paced the hospital room floor with a starving newborn begging for food. Although their hearts were in tatters and wanted nothing more than to feed their son, they knew his survival depended on the surgery he was about to have. He could not have anything to eat for a full day before the operation. This came after several days of losing all he ate.

A loving parent holds their child through the pain. Even when the child doesn't understand. A good parent braves the anger and tears, although they too are crushed.

> When they walk through the Valley of Weeping, it will become a place of refreshing springs. The autumn rains will clothe it with blessings.
>
> —Psalm 84:6 NLT

A grieving mother whose son had died by suicide was facing the first anniversary of the most horrific day of her life. She went on her Facebook page to express her dismay and hurt at how people were trying to make her feel better. Yes. She was upset that people were trying to make her feel better—telling her to get on with her life. She found the very fact they were trying to cheer her up, help her to get back to normal, as bitterly offensive. She expressed her shock by the subtle, as well as the not-so-subtle comments of people indicating it was now time for her to "move on." The comfort she felt just after the death of her son, the warm condolences and soft voices of compassion, were fading. What she once felt as a warm

cocoon of support was now collapsing under the weight of their expectations of her.

Of course life goes on. Life is still going on. This grieving mother acknowledged that those who once mourned alongside her and felt her pain had lives to live. They had tasks to perform, work to go to, plans to make, and dreams to chase. But for this grieving mother, it was still a time to mourn. One year was not long enough to absorb the impact of a devastating loss, pick up the pieces, and enjoy a world without her son.

> There is a time for everything, and a season for every activity under the heavens: a time to be born and a time to die, a time to plant and a time to uproot ... a time to weep and a time to laugh, a time to mourn and a time to dance.
>
> —Ecclesiastes 3:1–2, 4

Time and season. In God's creation, these two walk hand in hand. Just as it is time to work in the season of harvest so too it is time to mourn in the season of grief. Like any season, no one can say how long it should be.

## Comparing Grief

You don't have to lose a child to experience grief. Grief will follow every traumatic life-altering event—a diagnosis, a divorce, or a loss of a friendship, home, or job.

I once met a man who was still mourning his wife. He, not knowing of our loss, said to my husband and me, "They say losing a spouse is the worst kind of grief there is, even worse than losing a child." I just looked at my husband and nodded with understanding.

The only time to compare losses is within your own.

After losing my thirteen-year-old son, losing my eighty-eight-year-old mom to cancer, although extremely painful, did not compare on the pain threshold. They were not the same. It was two different types of mourning. Each one brought its own set of circumstances and relationship. That does not diminish the grief of losing an elderly parent. We cannot compare the depth of pain by individual circumstances.

Grief is love turned inside out. Grief fills the entire void it's given. The initial impact of grief is proportionate to the depth of love or value we have on what we have lost. How it affects one person cannot be compared to another.

For years I wished I could have been stronger for my children after we lost Dan. I wished I could have been the captain of our ship, guiding my family to a safe harbor during the worst storm of our lives. They wished that too. They all needed me.

But I didn't. I couldn't.

The Holy Spirit inside me did not give me the strength to stand, wipe my tears, and pretend all was well. Instead He gave me the strength to give in to the depth of sorrow and be changed by it. To walk into the valley of weeping and learn its lessons, to seek out the pools of blessings. That is where you learn to hear the voice of the Holy Spirit. That is when His love comes in like a flood.

Grief, sadness, sorrow—all these emotions are painful. We want to avoid them. Friends and family want to pull you out of them. They hate to see you sad, so they instinctively try to help you. They give you advice. Try to cheer you up. Or get you to look on the bright side. Not only are none of these tactics effective—they are not the right course of action. The pain, the sorrow, the grief needs to exist. You need to press into it, not avoid it.

The loss is worth its sorrow. My son was worth crying over. Your loss, whether it was your health, a job, a spouse, a marriage, or parents, are worth mourning over. They are worth being sad about.

You hear, "He would not want you to be sad all the time," as though to say you need to adhere to your loved one's wishes. Of course he wouldn't like to see you sad. No one likes to see someone sad. It is uncomfortable. It can make conversations awkward—mainly because people, in general, want to fix the pain rather than simply acknowledge it.

I've often told people it is okay to make me cry. Crying over my son is not a bad thing. Grief is not something you stop doing. It is something that becomes a part of you and helps transform your soul—if you let it. You will change. You can choose how you want to change. What will you do with the pain? Will you harness it?

The strength I received from the Holy Spirit was to live, to face my pain another day, to press into it and feel it for all its fury. Because that is what was true. To deny it, to pretend it didn't hurt the way it did, would also be to deny my self. More than that, it would push away the healing hand that wanted to catch my tears.

I am glad the Holy Spirit allowed my tears. When the pain and grief would overwhelm me, I fell apart. I cried as hard as I could—just not in the grocery store. It was in those times of crying, of allowing myself to fully feel the pain and weep, that a tiny part of my soul began to heal. If I held back, stuffed it down, and tried to "be strong," that is when grief would sneak up on me and knock me to my knees.

Grief is part of our lives for a good reason. It's a signal for change. It is the sign that something is very wrong.

Grief brings with it the deep groaning and whispers of the God who created life itself. It is as though the pain in your heart is so loud it drowns out the other voices. It has a way of sorting out life's priorities.

Mentally healthy people don't enjoy pain. In fact, we try to avoid it at all costs. We now have the option to take medicine to relieve us

of every discomfort—from headaches to sadness. We equate pain and sadness with something bad. What causes the pain and sadness usually *is* bad. However it is often the pain that tells us there is something wrong. Something must stop. There is an area of our life that needs our attention.

Pain is as much needed in a full life as joy.

One of the dangerous aspects of diabetes is the loss of feeling in a person's feet. It's called neuropathy. When this happens, the person can no longer feel pain. The nerves lose their ability to tell the person something is wrong, that there is an injury. A small puncture wound that is not felt can soon turn into a large, festering sore and the loss of a limb. In other words, the pain is there to prevent a larger wound. So too is our ability to feel the mental and spiritual pain of loss and separation. Sadness and even some forms of depression after life-altering events are not without purpose.

It is not something that must always be stopped.

Because we don't recognize our grief as a healing, restorative part of our lives, too often we push it away.

## Praise Smothers Pain

It was once standard practice, even expected, that someone who had lost a loved one would wear black clothing. A woman could cover her face with black netting. She was in mourning. They were not expected to jump back into society. To attend functions, babysit, or even smile much. They were allowed to wear clothing that told the world how they were feeling on the inside—dark. They were given the respect and space they needed to embrace their grief. How nice would it be to hide your bloodshot eyes behind a veil that said to everyone you meet, "I don't want to cheer up. It's not time"? As you know all too well, that is no longer the case.

Rather than withdrawing behind black fabric, today we are more apt to create the appearance of moving on. Strength is what we want others to see. Perhaps because other people lack the understanding of the depth of your pain that condolences slip too quickly into pity. Pity is no friend to grief. It's like running warm water over burned and blistered skin. It brings back the pain in a whole new way. We are expected to indulge in distractions from our grief because grief, and the process of mourning, is not respected as the healing season it is.

Although many people understand there are stages of grief, few of us understand their duration or impact—unless you are in the midst of it. While it's true there are stages or phases of grief, and we might pass through most of them to one degree or another, there is a danger in assigning grief to a script of stages. The stages of grief most people understand are as identified by Elisabeth Kübler-Ross:

1. Denial
2. Anger
3. Bargaining
4. Depression
5. Acceptance

When you read this list, it's easy to believe that they are sequential, and each has a set duration. You might even think that when a person goes through all of them they are then finished with their grieving process.

They can move on as though it were a completed checklist. This is simply not true. With life-altering trauma, the stages of grief are as linear as an uprooted willow tree swirling within the vortex of a

tornado. The winds may calm, some of the branches may have been broken off—but the uprooted life of grief remains.

Thrust by tragedy, the tree falls into the new world, and a new season begins. The name of this season is as unique as the person experiencing it. It is characterized by rebuilding. Like sprouts under ashes, new life is possible. But you must actively cultivate it.

The psalmist laments, "How long, Lord? . . . How long must I wrestle with my thoughts and day after day have sorrow in my heart?" (Psalm 13:1–2). Then he goes on to proclaim, "But I trust in your unfailing love; my heart rejoices in your salvation. I will sing the Lord's praise, for he has been good to me" (vv. 5–6).

The psalmist has given us a recipe for peace within the storm. Although he can see no end to the sorrow, look closely at what he is doing.

He is wrestling with his thoughts. He is grabbing a hold of and forcing into submission his thoughts. They are coming at him, but that can't hold him down. They are not ruling over him. They are not leading him into despair. They are not crushing the life's breath out of him. He is wrestling them and pinning them to the mat in submission. How do we know he is winning the match? The next few sentences paint the picture of how God begins the healing process. He is able to have joy, trust, and sing in the midst of great sorrow.

We were created in the image of God the Father. We, above all creation, can wrestle our thoughts and bring them under our control. We alone can accept a thought or dismiss it. We can meditate on it or push it aside. We can conceive of an idea and allow it to grow in the fertile soil of creativity or starve it to death with neglect. In times of sorrow, much of the turmoil is in wrestling our thoughts. They flood us and sweep us away. Grief itself is exhausting. It takes

effort to capture your thoughts and bring them into a place where they can give you strength and stop tearing at your soul. Later on we will go deeper, and I'll show you how to combine Scripture with emerging science to generate the kind of peace the psalmist is experiencing.

But first there is trust.

God's love is unfailing. His love can be trusted. The psalmist has learned to put his trust into the hands of God. It is unshakable. There is nothing circumstances can bring that will separate you from the love of God the Father. He is a good father. He is the essence of love.

His heart rejoices in your salvation, which means there is no shame or condemnation in your circumstances. You can find joy in the path God has set before you.

He sings the Lord's praise. A song is one of the most healing types of affirmations we can have. In the days following the death of my son, a couple songs gave me strength. One of them was "Praise You in This Storm."

Singing has the opportunity to put poetry to the groaning of your heart. When you allow words of praise to bubble up and out of your mouth, your ears take them in and soothe your soul. The song of my heart told God I thought He would save me from my pain by now. And yet here I am. Still praying, still hurting, still crying. The song acknowledges I can barely hear His voice. Then declares I will praise Him in the storm.

He is a good and perfect father who holds us when we cry and is not afraid of our anger. He wipes our tears, He doesn't make you swallow them or pretend there is no pain.

## Prayer

*F*ather God, I hurt. My soul cries. The night holds no comfort for me. When I am asleep my fears overwhelm me. I can see no future in a world where my heart is in tatters. But You are the God who sees me. You are the God who feels my grief. You created the love that was so deep its loss created a pain I never imagined I could survive. But here I am, Lord. My heart, I place into Your hands. My life, I place into Your hands. You alone know the answers to life. You created the seas and turn back the tides. You alone can turn my grief into peace. Heal my heart. Seal it with Your joy. I don't know what life has for me. Take this pain, my grief, and use it as a funnel to fill my heart with Your joy and understanding. Whisper to me the secrets of my life only You can reveal.

## Chapter 3

# Discovering a New Face in the Shattered Mirror

Maggy Lynn is Lolly and Eddie's first granddaughter. She was just shy of her second birthday, sleeping peacefully between her doting grandparents, when the penetrating sound of the telephone shattered their quiet moment together. Eddie quickly rolled out of bed to make the noise stop.

Eddie answered the phone and Lolly heard him say, "Yes, I am."

Then he stopped. He just listened in stunned silence. Lolly knew something was wrong. As he hung up the phone, he looked at his wife and blankly stated, "Edward is dead."

Hoping the loud, familiar sounds of falling water would mask their cries, Lolly and Eddie took turns pouring out the sounds of their agony into the shower. They didn't want their sweet Maggy Lynn to wake up in her grandparents' nightmare.

Edward and Millie were the couple's two grown children. Millie already started her family, and Edward was in his third year of college. The moment Millie walked through the door, she rushed to her mother and hugged her tight. As she pulled back, looking into her eyes, Millie gripped her mom's arms and pleaded, "I just want you to be the same. I want you to stay the same as you were before."

"Your mama will be okay," Lolly promised with a reassuring nod as she broke from her daughter's embrace. Grabbing her purse, she headed out the door to identify her only son's body.

Millie was afraid this loss would change her mama. Lolly, in her numbed state of disbelief, tried to comfort her daughter by letting her know she would be all right—still be there for her, still be her mama. Being the strong woman she is, Lolly believed the promise she gave her daughter that day with all her heart.

It was ten years later when Lolly recounted that conversation to me. With regret soaking into the memory she said, "I had no way to know what I was promising at the time."

It's normal for us to want things to remain the same. Especially if what we want is to hold on to the people we love and to the goodness in our lives. There was no way for Millie to comprehend what her mother was about to experience. Both mother and daughter needed, and wanted, the same thing—for this tragedy not to change their lives or relationship. That desire, as Lolly soon learned, was nowhere in the realm of possibility. What she couldn't have known was that it was okay for her to change. In fact it was important she did.

At the time her promise was made, Lolly was still absorbing an incomprehensible impact. For Millie, the loss of her brother didn't change her need for her mother. For Lolly, the loss of her son changed her entire world. It shattered who she was as a mother.

Our desire to cling to what we know as our normal and to not be altered is a natural response. Some might call it self-preservation. It's an automatic self-defense. We would be considered unstable, at best, if we easily let go of the people, relationships, and activities in our lives that matter the most. And yet when it is thrust upon us through a life-altering event, that is exactly what we are forced to do.

Unfortunately, all too often, it's those closest to you who believe they must pull you back into the life you had. Without realizing it, their need to maintain their stability gets blended into yours. Conventional wisdom says helping you rejoin life as it was before is the right thing for them to do—and is healthy for you. What they can't see is that you are now living in a different internal world.

## When Two Worlds Collide

Grief can stop time, twisting and tearing the past and present. It can violently transform your inner life and the physical world into two separate universes. One world moves in slow motion. The other keeps spinning, thrusting you into a completely new realm. There is the world where everyone else still lives and the world you are free falling into. In effect, Millie was trying to hold on to her mother's arms, hoping she could keep her from slipping away into that world—a world Lolly didn't want to go into. A world where her son no longer lived.

The new and old world can clash in unexpected places, like in the simple, daily routines of our lives. We enact daily rituals and form habits in order to create a comfortable familiarity. Sometimes they fall into place without us even realizing it's happening. That is, until they are gone—like my afternoon coffee. Almost daily, for the last year of his life, my Dan would round the corner from the kitchen into the living room sporting a giant grin. He would come to me and offer to make a cup of coffee for me. I would smile and thank him, fully aware of his underlying motive. Then off he'd go into the kitchen and make the fresh pot of coffee. His pigeon-toed gait would soon carry my coffee and his smile back into the living room. As he placed the hot cup carefully into my hands, he would ask, as though the thought had just come to him, "Do you mind if I have one too?" Of course not.

For days, weeks, and months after the accident I could still see him coming in to offer me his smile and fresh coffee. This memory, along with countless others, catalog what I once called my normal life. In the natural course of everyday life, one day only slightly impacts the following day. Overspending online Friday could impact the trip to the grocery store on Saturday. A babysitter calling in sick early in the morning can change the entire day's schedule. The impact of day-to-day events that shift our lives are easily absorbed, almost unnoticeably altering our daily lives. However, when your life shatters with a single event, it removes the simplest pleasures that color your life. The impact is instant and catastrophic.

Without a doubt, you have your own list of habits and routines that now have turned upside down. What was once a normal day is now uncharted territory. For Lolly, normal meant she was the proud mother of a college kid. For you, normal might mean you were part of two and now you are alone. Or normal meant you were healthy and self-sufficient and could take care of yourself, but now you depend on medications and others just to get through the day. Today's world could be drenched in pain, either physical or emotional—both can be crippling. Whatever the event, whatever the grief, today is not what life once was. Life has changed.

## The New Face in the Mirror

Following the summer of the accident, the changing of the season ushered in more than winter. It was the turning of a page and the closing of a chapter. The hot summer days of June, once punctuated with fierce thunderstorms, soon faded along with the flowers it brought. The cornfields started showing their age and bowed to the autumn wind. It became a visual step out of my old life. And away from my Dan. Away from what I once knew as my home, my

family, and even myself. Despite the fact I was unable to keep in step, the universe and all its rhythms refused to stop and mourn with me. The brisk air, the leaves falling helplessly from the trees . . . all whispered, "There's no turning back."

My life became a strange and unfamiliar place. Each day felt like another footstep further from the life I once knew. My life had been thrown to the ground, a broken mirror, its razor-edged shards scattered beneath my feet. Each piece was painful to touch—sometimes even to look at. When I tried to see myself in its refection, I was unrecognizable. The image was not one I could understand. It was unfamiliar and unwanted. Everything I considered important melted into a puddle of contempt: my writing, my flower gardens—even my precious daughter's wedding plans.

My friends and family couldn't see the fragmented reflection I saw. To them, I was still whole, just needing time to heal. What I saw was a distorted version of myself, one I didn't recognize. I once held a vision of what my life was. What my family looked like. What my future would hold. That image shattered in an unmarked intersection on a country road.

Maybe like me, you feel like those unrecognizable, shattered pieces. Fragmented. Or maybe you are still free falling to the ground with no sense of foundation and little to grab hold of to stop the descent.

In 1 Corinthians 13:12 (NASB) the Apostle Paul wrote, "For now we see in a mirror dimly, but then face to face; now I know in part, but then I will know fully just as I also have been fully known."

We all have our secret hand mirrors.

The reflections we see in them are the lives we believe we have. If we are honest with ourselves, we can admit to some extent we believe we see our futures. I don't mean seeing as in a crystal ball. Rather we have an image of the elements we believe our futures will hold. With the thought of summer comes plans for vacations.

We envision our children growing up, and they hold the hope of grandchildren. When we feel secure, plans for retirement and new homes are made. A young marriage brings visions of children playing in the yard. We believe if we do good, go to church, and love the Lord, bad things won't happen, and these dreams will all come true.

There is nothing inherently wrong with any of these visions. They are good. This is how we are made. We see visions of promise in our spirits. We live our lives and create our own little universes out of these visions.

When your life is altered beyond your control or imagination, the devastation reaches those future visions as well. This also makes the trauma so hard to overcome you feel lost. Not only did you lose the present, but you also lost your future. At least as you understood it. What you believed, hoped, and worked to shape— the future you wanted to create. When your mirror shatters, the image you thought you saw was gone or distorted beyond recognition. The fragments left behind reflect only parts of your life.

Scripture tells us what we knew, or thought we knew, was only seen in part—even when our mirror was intact. It was not the full reflection of our lives or who we are. We are not yet complete. Our lives are not fully known. The end of our story is not written. The riches of tomorrow cannot be seen today any more than the sorrow of yesterday could be foreseen. We have not reached the depth this life has to offer. We are yet to be fully known.

We cannot try to recreate what once was or the life we had any more than we can put together a shattered mirror and still reflect its original beauty. We have to allow God to reveal our places in this new reality. The first step is understanding survival does not mean forcing yourself to step back into your old life and pretend nothing has happened. Nor does it mean that just because time has passed you must pick up where you left off, and that will bring healing.

It doesn't.

Time doesn't heal—God, the Creator of life, heals.

It does mean stepping into a life you never wanted, reaching up for the hand of God and holding on tightly. It means trusting Him every minute and with every area of your life. It means that you must forge into this new world and ask your Heavenly Father to show you the way.

There is no going back. There is only going forward. As painful as that is, that is the real struggle you face. How do you do that when all you can see is what was? In order to go forward, you must have a clearer vision of what you are going forward into. The questions your heart is asking need answered. *What does life look like now? Will this pain be with me forever? Will I be the same? Am I broken beyond repair?* The answers will unfold one step at a time as you walk into this new world. In the coming chapters, we will uncover those answers together.

## Fragments of Reflections

Yes, the natural world around us lies. It proclaims life is still the same. As much as we fight it, change is a part of life. We would prefer to hold steady, keeping a comfortable and familiar lifestyle with the people we love.

Seasons change; so do we—sometimes gradually with passing years, like now, we are thrown into it violently. It's okay to change. You have that right.

Your first steps are into this new world, where it is not only different from what you imagined but you are also growing and changing along with it.

Does this surprise you?

You will be different.

You are different.

Give yourself permission to allow the impact of the life-altering event you are now facing to change you for the good. Consider whether or not you have allowed yourself to feel the full impact of what has taken place. Or are you simply pushing through? Are you trying to stay strong because that is what you believe is expected of you?

Let the world around you march on. It's your right to be in pain, to cry, as you step into this new and unfamiliar world, but you are not alone.

I didn't know the way on my own. I felt like a child afraid to let go of my Father's hand, frightened and trying to hide behind His leg. I didn't want to go down this path. This is not the road I chose, and yet there is no turning back. My first steps were unsure. But I found that our Father God is faithful. He alone can guide us safely through.

## The Puzzle of Our Lives

Have you ever picked out a puzzle based on the beautiful, intricate picture on the front of the box? The colors and the detail drew you in and challenged you to create it. Stated clearly on the box was the number of pieces that it takes to turn those fragments into a masterpiece. You know by the large number and the small pieces that many hours are required to complete it. Nevertheless, you buy it and take it home. The first thing you plan to do is find a spot to dump it out and then begin organizing the pieces.

Isn't that a little bit like our lives? We go into our adult years with the image of this beautiful picture of our lives. The number of children we will one day have. Maybe you even had names picked out before they were conceived. Maybe you already decided where you wanted to live. Or how big your house would be. Your own

puzzle of life, complete with the number of pieces on the side of the box.

Now imagine that before you had a chance to fully enjoy the process you were anticipating, you stumbled and threw the entire box high into the air, and your puzzle came crashing to the ground. All the pieces scatter to the floor. Some are now upside down. Many of the colors have changed during the fall. There are some pieces that are familiar; you remember seeing them on the cover. But now several pieces are missing. The picture on the cover of the box is now a memory as you stare at all the pieces before you.

The temptation is to focus on finding the lost pieces and defining the muddled picture that once seemed so bright and colorful. The missing pieces are the parts of the picture of the life you once had. These are the pieces you believe define the picture of your life. Without them, the picture is not the same.

What we don't realize in our daily life is the picture can't ever be fully seen any more than the future can. We can only see it dimly or in part. If we focus on the lost pieces only, we miss the real picture that lay in front of us entirely.

The pieces are not lost. It is a full picture that is intricate, complicated, and still beautiful. The picture of your life is being put together, not by you but by the unseen hand of a loving God. There are more pieces to our lives than we ever dreamed. Too many to count or find written on the side of a box.

Right now it probably feels as though you are still trying to gather the pieces together by yourself. With each new day, you feel forced to step into this world. You feel pressured to pick up another piece of the puzzle, a piece of your life, but it's not clear where it belongs.

Yes. The picture has changed.

You won't be able to see it clearly until your life is complete and you can see from heaven's view. That doesn't mean there

isn't so much to see as the picture comes together—the work here continues.

Picking up the pieces of your life is a painfully slow process. Each piece must be picked up, examined, and questioned. Some are completely transformed by circumstances. Others will take on new meaning. And, yes, we will find a few that have lost their value entirely. What was once of paramount importance may now mean nothing. Areas you once overlooked or took for granted will reclaim their rightful place. With every new day comes the same questions as you are forced to pick up another piece of your life. Is this piece still the same as it was before? Where does it belong now? Do I need to set it aside or pick it back up and hold it more tightly than before?

The new picture emerging is not the one you thought it was. And yet, we haven't seen the finished product. The masterpiece of you—who you were created to be.

## Memories that Grind

Memories of the life that once was can either capture and torture you or they can become a treasure to draw from.

During World War II, Corrie ten Boom saw the worst of humanity when Nazis occupied her home country of the Netherlands. Devout Christians, Corrie and her family hid Jews and members of the Dutch resistance in their home in Amsterdam. When Nazis invaded the ten Boom home, refugees remained safely hidden behind a false wall. Unable to be charged with harboring Jews, the ten Boon family was charged with having extra ration cards. By the time of their arrest, Corrie's family had saved the lives of hundreds of Jews.

Over the course of the following ten months, she and her sister were forced into three different prisons. By the end of the war,

she had lost her beloved father, a brother, a sister, and a nephew under the cruelty of the Third Reich. The ten Boom family suffered betrayal, inhumane conditions, and death. Corrie reached for the Father's hand. He walked with her into an unspeakable world of darkness. She emerged as a survivor of a notorious concentration camp near Berlin, Germany, into a strange, new world completely different from the one she had known.

"Today, I know that such memories are the key not to the past, but to the future," Corrie wrote in her book *The Hiding Place*. "I know that the experiences of our lives, when we let God use them, become the mysterious and perfect preparation for the work he will give us to do."

You are not in control of the change thrust upon you, but you are in control of how it changes you. You can decide to be forever transformed by it or allow it to disfigure you. To have so much pain and sorrow and to not draw from it all it has to offer is to compound the tragedy.

What you bring to the universe, even through your pain, is worth building and continuing.

You can decide that this new and unfamiliar path you are traveling will not be for nothing. Take the outstretched hand of Christ, and allow Him to lead you to put all the pieces together and find new ones.

> The LORD is close to the brokenhearted and saves those who are crushed in spirit.
>
> —Psalm 34:18

If you allow Him, Christ will help you make everything new. Priorities are realigned and relationships healed.

It is a painful process. But then, giving life always is.

God did not bring evil into your life. Rather He is the one who will lead you to your path of healing. He is ready to take your hand and walk with you.

But before you grasp His hand, you need to let go of the lies that try to push His love out of reach. Let's take a look at what might have slipped into your understanding about God and what part He plays in a shattered life.

## Prayer

*F*ather, I am reaching for Your hand. As I walk into this new world, I ask You to not allow it to create in me bitterness, anger, or regret. Take this pain. Use it to make me more like You, to draw me into Your presence in a way I've never known before. Do not allow it to consume me. Transform my sorrow into Your peace. Take my hand. I resolve that this new and unfamiliar path I'm on will not be in vain. I know it will change me. You alone, Lord, can take this pain and use it to refine me. Clear the lies from my life and my thoughts. Lead me through the narrow straits between joy and despair to the person I was created to become.

## Chapter 4

# Replacing Platitudes with Power

he clock beside Jeannie's bed kept whispering a truth she fought hard to deny. Another fifteen minutes pushed further into the night, and her daughter was still not home. She's never late. She always calls. Her phone is never off. Her daughter's phone went straight to voicemail. Even though she only worked fifteen minutes from home, she would always call if her plans changed. She was a good kid. Reliable. Hardworking.

Something was terribly wrong.

Jeannie got up for the third time to check her eighteen-year-old's room. The first two times Jeannie was too afraid to turn on the light. The thought of her daughter's disappearance was more than she could bear. An inner voice kept telling her to open her daughter's dresser drawers. But if she did, it would all be true.

The scene of their last minutes together kept running in a loop through her mind. How her daughter squeezed her shoulders with both hands then pulled her in with the tightest hug. She held on for so long it felt as though she didn't want to let go. It felt like a goodbye. In fact the thought, "She's running away to get away from me," flashed across her mind. But that notion was too horrifying to hold on to, so she dismissed it as quickly as it came. So she consoled herself, "She's just leaving for work."

Now, almost dawn, tormented by guilt, fear, and dread, Jeannie had to try again. This time, she would turn on the light. As she slowly opened the first drawer, then the second, their emptiness explained why her daughter's knapsack was so heavy. She's not late. She's gone.

It wasn't until the first rays of sunlight had a chance to enter the room that Jeannie saw the note left on the desk. It was like a finger of light pointing to a piece of paper with her daughter's handwriting on it. Fearing the note even more than the empty drawers, Jeannie mustered every drop of strength she had left just to walk toward the desk and pick up the small piece of paper. She was leaving, the note explained, and she hoped to see her mother again. One day. Not now. Not anytime soon. To ensure that moment wouldn't come before she was ready, she threw her phone into the ocean. She was running away.

It was at that moment Jeannie's life shattered. Not just with the disappearance of her daughter but at the realization she'd left because of her. Jeannie's secrets would soon be exposed.

When the police came to ask her questions about her missing daughter, Jeannie's shame filled her eyes. She was sure the officer would pick up on her nervousness and guilt. She had so much to hide, and it was visibly swelling inside her.

*How could she not know that her daughter was on the verge of running away? How could she miss that? How could something so important slip by her without notice?* The answer was both devastating and simple: it was because she was so wrapped up in her quest to fulfill her own needs she couldn't see her daughter's.

"I married the wrong man," was the lie she believed. So she set out to find happiness in the arms of other men. Romance addiction turned into a sex addiction, then she became lost to herself and to everyone else—even to her daughter. She was a good mom, at least that's what she always told herself in spite of her sins. Now

an empty room confronted her with a different story. It was a truth she couldn't deny. She was about to lose everything she loved.

Up until that moment, Jeannie believed the pain and loneliness she felt could be fixed in the arms of other men. She was wrong. Instead she became so tangled in her own lies, desires, and destruction she couldn't see the pain she was inflicting on everyone around her. Jeannie's life was broken by her own hands.

In her daughter's empty bedroom Jeannie called out to God in her pain, and He answered with His peace. While she was pleading for her daughter's life, God reached her heart and gave Jeannie her life back.

It was in the emptiness of that room that God filled Jeannie with His grace, forgiveness, and a wave of overwhelming peace. A peace so powerful it drove the darkness from the room—and her mind. From that moment on, she knew she would see her daughter again. She now had hope for the first time in many years. She also knew her life would never be the same.

It wasn't until Jeannie saw her life honestly that she could see the lies she had believed that led her to that moment. That's when she took her pain to her Father in heaven. He filled her emptiness with hope and grace.

## The Father of Lies

> Then Jesus was led by the Spirit into the wilderness to be tempted by the devil. After fasting forty days and forty nights, he was hungry. The tempter came to him and said, "If you are the Son of God, tell these stones to become bread." Jesus answered, "It is written: 'Man shall not live on bread alone, but on every word that comes from the mouth of God.'"
>
> —Matthew 4:1–4

Whatever God makes as good, Satan distorts. Satan knew Jesus had the power to turn the stones into bread. He wasn't testing Jesus' superpowers to see if He was really the Son of God. Satan knew full well who He was. Satan was offering Him a way out of His suffering. Jesus stomped out the thought upon arrival. He then countered it with the truth.

Satan came when Jesus was physically weak, and he distorted the truth. There was a real need for Jesus to eat. He, after all, was living in a very human body. Jesus had the power to feed Himself. Satan's purpose was to detour Jesus from becoming the man God intended Him to be and keep Him from living the life God planned for Him.

Satan distorts the truth and offers solutions to our suffering. When we don't cry out to God and say, "Lord, I hurt. Please fix me," the father of lies comes to us and says, "You hurt. Let me fix it." He gives us false reasons for the trials we face. Or he offers a counterfeit solution. Like reflections in water—it is the truth slightly distorted, shallow, reversed, and all too comfortably familiar.

No one is exempt from being lied to. Not even Jesus. Especially when we are hurting. It's part of our human condition. Too often we lie to ourselves. Of course we don't mean to or want to. It's just that we don't recognize them as lies because, well, they make us feel better. They are offered as a relief to our unhappiness or suffering we can't explain. Jeannie told herself that her sadness was because she married the wrong man. She believed she had a right to happiness. Which meant she had every right to pursue happiness in any way she desired. It was a lie and a reversed reflection of the truth. When she accepted it and acted on it as though it were true, it had ripple effects that carried her family far away from God's plan for their lives and the happiness she desperately sought.

## The Manufactured Why

As nineteenth-century philosopher Friedrich Nietzsche once wrote, "If we have our own why of life, we shall get along with almost any how." To this day, that quote is used in various interpretations from motivating salespeople to explaining the source of inner strength. However you will find only some truth in it.

Where there is the truth, you will also find the reflecting lie—a shallow imitation that is false, satisfying, and often deadly to the soul. We are all flawed, hurting people in search of a why. Why am I not happy? Why did this happen to me? Why did God allow this to happen?

To one extent or another, we have all been damaged by the world we live in. No one goes through life without pain. As a defense mechanism, we make up our own why, not only for our own sin but also for the bad things that happen to us, so we can accept them.

It is a human need to understand what is happening to us. There's nothing wrong with that. We try to process and label tragedy to give it some kind of meaning. We attempt to make the unthinkable comprehendible. Now with social media, the most popular and plausible explanations are shared and turned into memes, greeting cards, and poems. Eventually some variation is adopted into everyday life as though it is truth, and then it quietly seeps into our faith.

I call these trite phrases bumper sticker theology.

Bumper sticker theology is a catchy cliché that easily rolls off the tongue. It sounds right. There is a teaspoon of truth in it. Like Jeannie's "right" to happiness. That's what makes it so dangerous. It has only enough truth to make swallowing it whole effortless.

So we do.

Without examining its contents, its impact, or possible ramifications we take it in and allow it to become part of our belief

system. Jeannie believed she had a right to be happy. Her pursuit of that lie brought the exact opposite down upon her entire household. It's the simple, bite-size lies that we take in with little or no thought.

It's common in our fast-paced culture to grab a passing blurb of granular truth without looking deeper to see if it holds any substance. Let's step back for just a minute and look at the world around us to see just how subtle and common this type of thinking is.

## Coexist

Have you seen the bumper sticker with the word *coexist* whiz by? It is artistically written with symbols of the world's religions intertwined, forming the word *coexist*. Among the most recognizable are the Christian cross, the Jewish Star of David, and the Islamic crescent moon and star.

Of course, what the world needs is peace. That is the truth tucked in.

To love one another and live in peace with all religions is right and should be true. After all, isn't that the original American dream? To live where you are not persecuted for your faith? The world would be a much better place if all the religions of the world could coexist in peace. Again, this is true. What is also true is that throughout history, from the Crusades to the Catholic and Protestant wars to the Holocaust to ISIS, untold lives have been lost under the symbols of religion. In many parts of the world, Christians and Jews are still being slaughtered for their faith. It is still happening at this very moment just as it did centuries ago. The only difference is enemy forces have weapons that can produce death on a larger scale.

*Coexist* is an example of a surface truth. The depth of reality is revealed within these three religions alone. Powerful factions

within one believe the other two have no right to exist at all. Those of us in America, who proudly display this particular bumper sticker, have nothing to lose by doing so. I've often wondered if they have asked a Coptic Christian living in Egypt (their ancestral home) what their coexistence is like. Or have spoken with a family in Israel trying to raise their children while under constant threat of missile attack. If they did, they would hear stories of death, destruction, and persecution of their faith.

Please understand; I know these are well-meaning people. I'm not disparaging their sincerity. However, they are displaying a simplistic understanding and solution without fully understanding the depth of the pain they are talking about. It's a call for peace in the world. A noble gesture. They freely display their bumper sticker theology for the world without a clue to the depth of the issue they are addressing.

So too are the well-meaning people who want you to have peace in your life. They offer their bumper sticker theology. It permeates the culture, and because it does, it also leaks into our faith without notice. We have all been victims of bumper sticker theology to one extent or another. But I don't think there is a more hurtful or more dangerous time to adhere to this kind of thinking than when you are trying to put together the pieces of your life.

Let's examine a few more subtle bumper stickers the father of lies has created to adhere onto your faith. These are just a few of the platitudes and self-soothing theology that is passed around like three-dollar bills. They are fundamentally flawed, hold no real-world value, and must be rejected. These are man-created whys that are a distorted reflection of truth.

Like those sporting *coexist* bumper stickers, the well-meaning people hand these trite phrases out, having not explored the depth of the issue or experienced the pain they are attempting to

mend. Before you accept them as truth, they must be held against Scripture and the very nature of the living God.

## Everything Happens for a Reason

Perhaps the most common platitude, second only to "you have a right to be happy" is "everything happens for a reason."

Does it really?

It often feels like there *must* be a reason. This is the central point of creating our own why. We feel a need to know that there is a reason for our suffering. Let's look at that platitude a little closer. It's given as life's get-out-of-jail-free card for every situation as though to say, "It's all good. You'll see there's a reason this happened that will turn into something good for you." If everything happens for a reason, yet to be revealed, then explain:

> What good reason is there for a father to leave his family for another woman?
>
> What good reason is there for an infant to die before birth?
>
> What good reason is there for a child to die in a car accident?
>
> What good reason is there for a mother to die before she sees her first grandchild?
>
> What good reason is there for cancer to ravish a body?
>
> What good reason is there for a teenager to commit suicide?
>
> What good reason was there for the Nazi extermination camps?
>
> What good reason is there for genocide, slavery, and poverty?

I could go on. No doubt so could you. The list is as long as human suffering itself. When the "everything happens for a reason" motto is thrown out to cover a bad situation, the good is implied. To say everything happens for a reason means there is no true evil. There are no accidents. You have no free will. All of life is predetermined, predestined, and fully scripted. It implies we must accept anything and everything that happens in our lives—because it has happened for a God-ordained, pre-determined reason. Which also means evil is nothing more than a vehicle to bring good. So let's ask ourselves, what truth is this lie a reflection of?

> And we know that in all things God works for good of those who love him, who have been called according to his purpose.
>
> —Romans 8:28

The truth explained in Romans is twisted and turned upside down in the "everything happens for a reason" catchphrase. God loves us and wants to bring something good out of our pain. We will dive deeper into this in the coming chapters. But for now, let's look at the nature of God. To see the nature of God, we can take a closer look at how he reveals himself in creation.

Consider the forest fire. A raging fire consuming everything in its path is a terrifying sight. From the mightiest oak to the deadliest predator, everything can be devoured by flames. To compound the loss, the wildlife that survives is left without food. From the human point of view, it is tragic. So much so, men and women put their lives on the line to stop it.

And yet there are some species within the forest that, without the fire, would never sprout. The lodgepole pine and the Eucalyptus

bear fruit that is completely sealed with resin. Only fire will release the seeds within. Fire clears thick overgrowth and allows the sun to call out native plants once again. It can eradicate diseases and destructive insects, allowing wildflowers to come alive again and flourish. Young trees that would not have had a chance to survive now enjoy a growth spurt because the foliage of old trees is replaced with sunlight.

Scientists tell us that young-growth forests, coming back from the fire, become home to a more diverse wildlife population and vegetation. Is it the same? No. It is, however, alive, and it thrives with new and abundant life.

The "everything happens for a reason" dogma is the reflection of the truth that our Creator, who makes the rain fall, calls new life out of the fire's ashes.

## God Never Gives You More Than You Can Handle

This candy-coated euphemism is often given as an encouragement, to say, "You can do this." It's important to notice this phrase has two parts. First, it implies God has brought this upon you. And because He is giving it to you, He won't give you too much of it. Does God bring death, evil, calamity, and hardship to His children? Would you bring death, evil, calamity, and hardship purposefully into your children's lives?

Christ referred to God as a father. He prayed to "our Father" in heaven. God has revealed Himself to us as a father. Consider the nature and love of a good father. Would you as a loving father bring evil into your child's life? "If you, then, though you are evil, know how to give good gifts to your children, how much more will your Father in heaven give good gifts to those who ask him!" (Matthew 7:11).

Second, it implies it will all be okay. It says He knows what you can handle and where your breaking point is—and God's not going to allow that to happen. Would you force your child to carry a load of bricks so heavy he collapses but not heavy enough to cripple him? Would you send only enough pain in the life of your daughter to make her want to die?

No. Of course not. And so just as we, as flawed, imperfect parents, want only to give good things to our children, so too does the author of love, our Heavenly Father, want only to give us good things. He does not take our children, destroy our marriages, or plague us with addictions. We are often faced with more than we can handle. Life itself is more than we can bear without His help. We were not created to walk this earth alone. We were created to be in communion with our creator.

Oftentimes, due to the lies we've ingested, we become victims of our own sin. We were not created for death or to live our lives drenched in sin. We were created to walk with God the Father. He is not the one bringing pain into your life. He is the one with the outstretched hand offering a peace that only He can bring.

When we reach out to Him in our weakness, He answers. "God never gives us more than we can handle" is the distorted reflection of the truth that when we are weak, He is strong. Our Heavenly Father gives good gifts to his children.

## It's God's Will

Nothing maligns the character of God more than attributing tragedy to God's will. It's just another version of "everything happens for a reason." God's will is carelessly tossed around as a reason to accept whatever befalls us without question. There

is, of course, the need for us to seek God's will; this is not what I'm referring to. Well-meaning people throw God's will at your circumstances in order for you to accept them. They don't understand the nature of God—nor His will for your life. It wasn't until I was standing in the receiving line for my son's funeral that I saw how bumper sticker theology, masquerading as poetry, can distort faith in a loving God.

As I stood beside my son's casket, an elderly woman came up to me and clasped my hand in hers. She was sweet and tender. She was the grandmother of the other two boys who were in the truck with my sons when the accident happened. Her grandsons were still in the hospital, perhaps still in intensive care. I'm not sure; that time is still a very hazy memory. Even so, I'll never forget her face as she took my hand and looked deeply into my tear-filled eyes and said, "God just needed another rose in his banquet table bouquet."

While it may have sounded wise and comforting on a poem she read somewhere, it was a horrifying thought to me. God is not a monster who takes those we love to decorate heaven's party tables. He does not take children out of the arms of parents. He wipes their tears and welcomes them with open arms.

He does not need them more than we do. God is the creator of life. Satan is the thief that destroys life. "The thief comes only to steal and kill and destroy; I have come that they may have life, and have it to the full" (John 10:10).

It is God's will that we have a full life. Let's take another look at creation to understand God's nature.

Take for example another common disaster we face. Unlike forest fires, oil spilled can be completely the fault of man. The BP oil spill in April 2010, known as the Deepwater Horizon oil spill, was considered the largest marine oil spill in history with

an estimated discharge of 4.9 million barrels. Volumes could be written on the disaster and its impact on marine life. It was tragic on many levels.

One aspect you seldom hear about when it comes to oil spills is that there are naturally occurring, oil-eating microbes that help clean the waters and shores. Remember those wide-mouthed, hungry yellow electronic balls in the old Pac Man video game? Imagine a microbe just like that. When God created the oceans, He seasoned it with those hungry little guys. Only they are oil-eating microbes. That's right. There are microbes already in place to eat the oil spilled in the ocean. From the beginning of creation, God prepared a way. He was prepared for man's twenty-first century disastrous blunders.

Scientists have learned how to fertilize these tiny microbes to energize and grow them even more robust so they can be unleashed in oily waters to devour hydrocarbons. They are one of the smallest life forms on the planet, and yet their purpose is to ease the suffering and impact of one of the most devastating man-made events in nature.

"It's God's will," is the reflection of the truth our Heavenly Father is the giver of life and has given us a free will, and yet he has provided for all of our failings.

There are no platitudes, memes, or poems that can make the darkness in our lives acceptable. There isn't a substitute for the grace and love God has for you. The complexities of the universe and man cannot be summarized in a packaged slogan. There is evil in the world that cannot be dismissed or explained with a catchall phrase. There is injustice and pain that is a reality that must be confronted—not glossed over. It grieves us. It brings us sorrow. It brings God the Father sorrow. We were made in the image of God, which also means we grieve loss, injustice, and evil. Suffering and

pain are part of being made in the image of God. We grieve for those we love who go before us, just as God grieves the loss of those who reject him.

## Meaning Gives Hope

Several years ago I heard a pastor tell of an encounter he had while working in his yard late one afternoon. He decided to make a quick trip to the local nursery to grab just a few items he needed to finish his project that evening. The store wasn't far from his home, so the trip itself only took a few minutes. He hurried around the aisles and gathered the supplies. Spotting the shortest line, he was feeling pretty good about his efficiency. Total time spent shopping was just under ten minutes.

What he didn't notice, although there were only two people ahead of him, was the woman already checking out. She had two carts filled to overflowing with plants. The inside of the cart was piled with pots. Hanging baskets clung to every side, including the handle. Bushes were bent over and stuffed underneath like an overgrown child taking a ride. She had flowers, shrubs, and vines. It looked as though she was trying to pack one of everything in the store into her carts.

The clerk was doing his best to be swift and courteous. In spite of his best efforts, you could see the stress level rise in his face every time he caught a glimpse of the growing line. Before he could get the first cart emptied, the shortest line had grown into the longest. It was now flowing into the aisle behind them. This pastor shamefully admitted he was becoming increasingly frustrated. As the clerk dug deeper into the cart, pulling out plant after plant, the pastor's plans for a quick return faded into an angry submission to circumstance.

At last, curiosity got the best of the young clerk, and he asked the question everyone in the line was thinking. "You have quite a bit here. Do you mind if I ask why you are buying so much?"

"Not at all," said the woman. "It's my friend," she began with a catch in her throat, "she was just told she has stage four cancer." She swallowed hard and continued. "She has always wanted a flower garden—and I'm going to give her one." The strength of her determination lifted her voice a little louder than she had intended. Everyone in line heard her. And suddenly, no one cared how long it took to get on with their day.

The why infused with meaning forges strength and endurance. What if the suffering you are forced to endure can bring forth a new you? What if, like fires in the dense forest, your sufferings clear out the overgrown brush from your life and gives way to new life? What if it allows light in where you were incapable of seeing it before?

Yes, it's a different life. This is not the life you dreamed of. And it's certainly not the one you asked for. But it is life. Jesus came not to wipe out all sorrow but that we may have life, an abundant life.

## Fragments of Reflection

We have to choose who we listen to. Scripture tells us in the Book of Job that Job's so-called friends came to sit with him while he was mourning. He had lost his children, his wealth, and his health. They came to comfort him; instead they spouted their own wisdom.

God said:

> Brace yourself like a man, because I have some questions for you, and you must answer them. Where were you when I laid the foundations of the earth? Tell me, if you know so much. Who determined its dimensions and stretched out the surveying line? What supports its foundations,

and who laid its cornerstone as the morning stars sang
together and all the angels shouted for joy?

—Job 38:3–7 NLT

I don't know why children die. I don't understand why I can't live
up to my own expectations. I don't understand why some people
are blessed with many children and others beg for one. Why we
can put a man on the moon but can't cure cancer. There are infinite
questions I could ask. The living God of the universe cannot be
stuffed in a box or mocked by the wisdom of man. There are no pat
answers. There are no easy fixes. The plain, hard truth is that to live
is to experience pain, sickness, and death. *But You, God, bring mercy,
peace, and joy where there is none.*

Have you allowed your faith to slip away into comfortable lies?
Or listened to people who try to smooth over the turmoil in your life
with platitudes? Are there thoughts you need to reject?

## Press into the Suffering

At the beginning of World War II, Viktor Frankl was faced with
a decision. His passage was secured for his escape to America.
However, to go meant he would have to leave his parents behind
to face the distinct possibility of concentration camps. He wrestled
with what he should do. As a psychiatrist, he believed in his work.
His therapy, which became known as logotherapy, was still in its
infancy. He could escape to America and live out his dream to give
life to his brainchild. Or he could stay behind and be a good son and
take care of his parents.

As he wrestled with this dilemma, he noticed a piece of marble
in his father's home. It was a piece his father found on the site
where the Nazis burned down a local synagogue in Venice. His
father took it home because it was part of the tablet of the Ten

Commandments. It was just one Hebrew letter that stood for the commandment, "Honour thy father and thy mother: that thy days may be long upon the land" (Exodus 20:12 KJV). It was in that moment Frankl decided it was no accident but rather a sign from God, and he chose to stay home with his father and mother. Life took a very dark turn with that single decision.

It was deep within the suffering of the notorious Auschwitz that Frankl discovered his theory was correct; it was not the pursuit of pleasure that gives meaning to life (which was the prevailing philosophy of his day as it is today). It is meaning. The meaning that each of our lives brings to creation.

As a being created in the image of God, you have a unique purpose on this earth. No one can replace you. Those who leave before their time leave the world a lesser place. Those who, like Frankl, bear the weight of deep sorrow show us we can also find meaning in our lives. In his book *Man's Search for Meaning*, Frankl wrote:

> **We must never forget that we may also find meaning in life even when confronted with a hopeless situation, when facing a fate that cannot be changed. For what then matters is to bear witness to the uniquely human potential at its best, which is to transform a personal tragedy into a triumph, to turn one's predicament into a human achievement. When we are no longer able to change a situation . . . we are challenged to change ourselves.**

We cannot change what has happened. We might never understand why life has taken such a turn. There is nothing shallow about the suffering we face. God also suffers along with His creation. You are loved, and He feels your sorrow.

When God created man, He did so in His own image. He formed him from the dust of the earth and breathed life into his nostrils. With it, we inherited the need for good, justice, and peace. Like our Creator, we grieve sin, evil, and separation from Him. It is not in our nature to blindly accept evil in the world, whether done to us or by us. For any reason. So we manufacture or accept a counterfeit why in place of meaning.

While circumstances cannot be changed or explained, the ability to govern how we react to them can never be taken from us. We can choose to embrace the pain and suffering set before us and use it to force us into more than we were before. Nothing can take that away—not even a death camp. No one can change that. It is your birthright.

Today you can choose to trust. You do not need to embrace shallow platitudes as to why something happened. Through the coming chapters, we will wring out what the God, who brings forth new life after a fire, has to offer. We can't stop the fire. We are already in the midst of it. But we can trust that new life will spring out of the ashes.

We can allow God to transform us through our pain. To purge deep within what has kept us from reaching out to the Living God and allowing Him to breathe new life into us. It is your choice to press into the fire and be transformed into the person God created you to be, refined by the fires of unyielding circumstances. Or you can allow the flames to twist and distort your life, rendering it unrecognizable and useless. Transformation begins with the renewing of the mind. Your mind is the battleground for your soul, for your happiness, for your survival during those darkest hours. Your Heavenly Father has given you the ability to bring new life out of destruction. Let's look at how He has already equipped you.

## Prayer

*F*ather God, look deep inside my heart. Use the pain I feel to reveal the light of Your truth. Wipe away from my mind any and all shallow reasons for my pain that others want to give me. The pain I feel is real, raw, and hurts to touch. Show me only Your truth. Allow me to see that, while I don't understand the why of my suffering, I do understand You are the Creator who brings life from the ashes. That You and You alone can take this life of mine and bring forth something new. Take my heart and make it new. Allow me to see Your light where I couldn't before. Keep from me the shallow platitudes of those who need to make their own why. I don't need to make my own why for the suffering I feel. I need only to trust that You will use this pain to forge a new life, one that is abundant with Your presence. I trust You with my pain. I won't hide my hurt from You—I place it in Your hands and trust You to give it meaning.

# Chapter 5

# Capturing Your Wandering Mind

Now faith is confidence in what we hope for and assurance about what we do not see.

—Hebrews 11:1

There's little I remember about that first Christmas after the accident. Christmas was always a big deal for me. It fed my creativity. I loved making the atmosphere feel like Christmas with music, warm lights in the windows, and a house filled with the scent of cinnamon and vanilla. That's the kind of Christmas our big family could always afford without Daddy having to work overtime. It was about creating childhood memories. Nonetheless, those were concepts and emotions completely out of my reach that year. The children and grandchildren still living at home kept asking me when we would put up a tree, when we would begin the traditions I had always held up as so important. It wasn't until the last week before Christmas that I gathered enough strength to go through the motions of decorating the house and buying gifts.

That Christmas Eve my friend Debby arrived home from her annual last-minute power-shopping extravaganza. I drove down the road to her house to exchange our small Christmas gifts. Her home has always been one of my favorite places to sit and

visit—sometimes for hours. Her century-old farmhouse holds all the charm of stepping back into the 1800s. Five generations of her husband's family have lived and raised their children in her home. Hand-painted portraits of past generations adorn the walls. Where most houses have a formal dining room, hers still has a parlor with a couch facing a wood-burning stove. Her deep-pumpkin colored walls hold the faint hint of wood smoke that sinks a warmth into your spirit. I expected to see the usual shopping bags hiding gifts awaiting a late night session of frantic wrapping. I expected to see children playing with new toys on the floor. It never occurred to me I would see my Dan.

As I walked into the living room, I saw my boy's best friend, Debby's son, Wesley. He and Dan, only months apart in age, were inseparable since they could walk. There he stood behind a three-foot-tall Ferris wheel he just made. Much the same way Dan made his space shuttle with his nephew Zachary, Wesley had spent the day building his Ferris wheel with younger siblings. It was a scene that, had the accident not happened, my boy would have already been there for hours building alongside Wesley. But he was not. Dan was gone. And yet I felt his absence as strong as though he had been standing there.

Everyone else in the room saw what was there. All I could see was the one who was not. I felt as though there was a huge rip in the curtain of air next to Wesley. A shroud of what is and what should be hung in the room over a hole the size of one teenaged boy. As my eyes looked past Wesley and stared at the void, the voices around me began to fade. For just a moment I couldn't see what was before me. Instead my mind's eye could only see who was not there. Grief swept over me, swelled up in my chest, and caught in my throat. I could feel my imagination take control of my mind. It began telling me stories of what should be.

Not wanting to spread my blanket of sorrow over Debby's Christmas, I pulled out my fake smile, pasted it over my thoughts, and got out of the house as quickly as I could.

I had allowed my mind to wander into dangerous territory.

## Weapon of Hope

The most powerful weapon God has given us is the power to harness and propel our thoughts. Like a high-powered rifle, your thoughts have the capability to defend you and keep you safe in a spiritual or emotional attack. However, turned in the wrong direction, your thoughts are deadly. As a being made in God's image, you are a thinking being. You are an intelligent being. You were gifted with a free will. Above all creation He has granted mankind the ability to separate ourselves from our thoughts and examine them. This is the essence of a free will—to judge, accept, or reject your own thoughts. You can turn against your own nature and create within yourself a connection and pathway to your creator. You can see what is not there. You can conceive within your own mind the future you want and create it.

We can harness thought and use it to create in the real world what we conceive in our mind—we can use that power for both good and evil. This is your free will.

> This day I call the heavens and the earth as witnesses against you that I have set before you life and death, blessings and curses. Now choose life, so that you and your children may live and that you may love the LORD your God, listen to his voice, and hold fast to him.
>
> —Deuteronomy 30:19–20

We have the gift of the ability to choose how we will use our minds. Every action begins with a thought that is either accepted or rejected. Thoughts that can come into our mind and show us visions we don't want to accept. Our own thoughts can horrify, delight, and give us hope. And like they did that Christmas Eve, they can paint pain over a canvas of happiness.

In Judaism this duality of the mind that battles for your soul is called the *yetzer hara* (evil inclination) and the *yetzer hatov* (good inclination). Jewish tradition says we are born with the *yetzer hara*, or sin nature, then around the age of thirteen, the *yetzer hatov* is born. In Christianity, many refer to it as the age of accountability.

Like our childlike propensity to selfish pleasure, our mind naturally wants to wander on its own. Where it goes depends on what boundaries we give it and where we allow it to go.

It's important for us to remember that we have the ability to accept or reject the thoughts that come to us. Each thought that comes into your mind is either accepted or rejected. If you don't reject it, it falls quietly like a snowflake onto the banks of your subconscious—and soaks in.

It is the power of thought fortified with faith that was at the root of Viktor Frankl's theory of survival in the concentration camp. Frankl believed it was the will to live for a purpose, whether it was a great love or work yet to be accomplished, that brought a sense of purpose and enough meaning to life it enabled him to overcome death in a concentration camp. Purpose, meaning, and love are all conceived and accepted or die in the realm of our thought life first.

Frankl's life was truly shattered. Everything was taken from him. Everything. His home, wife, parents, his work, every earthly belonging. The shards of his shattered life that were left, he found, was his ability to hold on to what mattered most in his

life. The thoughts of love for his wife. The purpose he believed for which God had placed him on the earth. And his ability to choose how he would react in every circumstance—no matter how evil or grim.

Frankl witnessed, under the worst of human conditions, what the mind can overcome. He discovered that meaning in life can be found through and during times of deep suffering. Sorrow is a powerful force for change. What he learned is that when you are forced into a situation or circumstance that is hopeless, when you are faced with a fate you cannot change, that is when you hold the power to truly change everything. You can create a paradigm shift, first in your mind, then in your physical world. He fought his Nazi captors in the battleground of his own mind. He not only survived, but he came out a stronger person—one who went on to fulfill his unique purpose.

What science is revealing to us is how the Scripture that instructs us to renew our mind is vital to our life, survival, health, and happiness—not only on a spiritual level but a physical level as well. You can allow your pain to soak into your spirit until it changes the very essence of who you are or you can take the power of that suffering and use it to press into the God who knows what you are capable of and who He created you to become.

How do you harness the pain? How do you let it sculpt rather than crush your spirit? The same way you channel a river. You don't stop it. You don't dam it up. You channel it by putting rocks in its current. You allow it to flow, but you direct its course. We can bring into captivity every thought. We can't keep all thoughts from entering our minds, but we absolutely can decide if we will keep or reject them. We can set guides as to where the flow of thought is allowed to go. The renewing of your mind will shape your thoughts, soul, and even your physical body.

## Thoughts Are Things

We can create our own reality with our thoughts. The battle for happiness within a world you never imagined living in begins with your thought life. The renewing of your mind means you can recognize the thoughts that are creating a different reality from the one you want to live in.

When you keep a thought that is not true or that is hurtful and toxic, it is like pulling a heavy wool blanket over your head. "I can never be loved again." One layer. "My marriage was a mistake." Another layer. "No one wants me." The layers are making it hard to breathe. "I am ugly." The layers are so heavy you can't see through them any longer. "I am not worthy of love." A final layer cripples your spirit under its weight. Each of these thoughts, when accepted, is a heavy blanket over your soul that smothers out the air of truth. How can you stand up and walk out of devastating circumstance when you are covered in the weight of lies?

You can't.

Layer after layer of toxic thoughts smother you as sure as though they were actual blankets over your head. You can't see where you are going. The weight makes the simplest moves in life almost paralyzing.

Scientists can now see what happens when the brain has thoughts. Neurons form branches like trees. They spread and create actual new brain cells. Your thoughts create matter within your brain. They build and structure and restructure your brain. They create patterns.

You can remove the blankets that smother your peace and obstruct your view of God's will for your life. Your worth is not defined by your circumstances. But you will define your own value by the thoughts you hold and keep within your heart and mind.

Each one of the blankets you have allowed to cover you with a lie must be pulled out and examined. Is it the truth? Or is it Satan's fix? Have you decided that it holds warmth or only a false sense of security you want to hold on to?

When you are in mental and emotional pain, your mind will try to find comfort, even an escape. In my darkest hours, it told me of the man I would never know in the boy I lost. My thoughts taunted me, whispering images of what might have been. The grandchildren I would never see, his stories I would never read, his arms I would never feel again. When we wade into the pools of thoughts that bring us more sorrow, there is just enough comfort that can make us want to stay there. But like a dark, deep lagoon, those waters have undercurrents of lies that Satan will use to pull you under.

They don't have to be blankets of lies. The harsh reality of truth, when waded in without the life vest of hope, is also deadly. It is too easy to see what is not there. It's true. I will never see my son as a man. Sometimes it's harder to see what is in front of you.

> Do not conform to the pattern of this world, but be trans-formed by the renewing of your mind. Then you will be able to test and approve what God's will is—his good, pleasing and perfect will.
>
> —Romans 12:2

The renewing of your mind is not just an exercise in positive think-ing. It is not a tool to get you a new car, a bigger house, or riches. However, it is the path to a sound mind and a full life, even in the midst of tragedy and immense pain. It is peace even in the darkest circumstances. It is how to put your life together in a way that not only pleases God but also brings you the direction and peace your soul longs for.

It has far more physical, mental, and spiritual power. Your thoughts matter. Your thoughts are matter.

> Casting down imaginations, and every high thing that exalteth itself against the knowledge of God, and bringing into captivity every thought to the obedience of Christ.
>
> —2 Corinthians 10:5 KJV

## Time Travel Has Never Been Safe

When your mind wanders back into time, it can easily drift into despair. When you locate the point where the events might have changed, a new wave of grief will wash over you. You are powerless to change the past. Your mind and your heart are trying to survive.

Your heart is critically wounded, and your mind is your battlefield medic. It is your lifeline. Your mind can bind your wound. But, like a frantic medic on the battlefield looking for something to stop the bleeding, our minds also search for answers—always looking for the why. Imagine a medic on the battlefield who constantly strays away from his wounded on the ground and wanders instead into the enemy's camp to watch in horror as the enemy kills, robs, and destroys. That's what happens when we allow our minds to wander into areas that lead to hopelessness and despair. There must be clear boundaries as to where you will allow your mind to go. Only then can the mind apply the right pressure to the wound to ease the pain, and the right thoughts are like a fresh supply of life-giving blood and oxygen.

Dr. Caroline Leaf, a cognitive neuroscientist, explains the science behind what Scripture refers to as renewing your mind in her best-selling book, *Switch On Your Brain*.

**When you objectively observe your own thinking with the view of capturing rogue thoughts, you in effect direct your attention to stop the negative impact and rewire healthy new circuits into your brain. The ability to quiet your mind, focus your attention on the present issue, capture your thoughts, and dismiss the distractions that come your way is an excellent and powerful ability that God has placed within you. In the busy age we live in, however, we have trained ourselves out of this natural and necessary skill. *Natural* because it is wired into the design of the brain, allowing the brain to capture and discipline chaotic rogue thoughts.**

When you determine to capture your own thoughts rather than allow them to hold you captive, you are literally rewiring the circuitry of your brain. The renewing of your mind is not just a spiritual term. As thoughts direct the neurons in your brain, the physical renewing of your mind ultimately renews your life.

Dr. Leaf goes on to say, "It calms our spirits so we can tune in and listen to God. When we are mindful of catching our thoughts in this way, we change our connection with God from uninvolved and independent to involved and dependent."

In Psalm 46:10 we are told, "He says, 'Be still, and know that I am God.'" Being still means quieting your mind. Learning to listen. When you begin to be careful of the thoughts you allow to come into your mind, then you will find you are freeing space for God to speak to you.

It has often been said you are a spirit, you live in a body, and you have a soul. We are complex beings made in the likeness of God. We were created with three levels of a conscious mind.

You have a conscious mind. It is your carnal mind. This is where the *yetzer hatov* and *yetzer hara* lives. It houses your reasoning

abilities, and out of it comes your free will—the choices you make on a daily basis to follow your conscience—good inclinations or not.

Then there is your subconscious. It is the database of your life's story. It has an always-on feature. It records every event of your existence, perhaps from utero to the reading of these words. It is not fully accessible to the conscience mind, but it speaks to it through emotions, creativity, and even dreams. It may not always be understood or accessible on a conscious level, but it is always influencing you. While you are not fully aware of it, it affects your feelings, choices, and behavior. The subconscious mind is where anxiety and the secrets we push down to hide store their feelings. And finally there is our super conscience, or what we know as our soul. It is the part of our mind that allows us to hear from the God of the universe, our creator. Because it is eternal, it has the ability to hear and speak to the eternal.

Who hasn't experienced the inner turmoil of these three parts of ourselves as they wrestle for control within us? In some instances, when circumstances seemed overwhelming, I have physically felt these parts of my conscience wrestle. My mind wants to overtake my intuition. Then when I try to trust my intuition, worry sneaks in and creates doubt, making me wonder whether or not it was God's voice I heard or my own mind. Then the wrestling match starts all over again. This inner thought life encompasses our humanity. It may sound all mystical, or overly religious, but it really is an everyday part of life that we don't take time to break down and see what is happening—let alone take control of it. Too often we allow these thoughts to run rogue and control our lives. They create strongholds within us. They limit us. They keep us trapped in the prison of our circumstances. We allow our thoughts to make deep patterns in our thinking that keep us trapped in a life we were not born to live.

When we allow our mind to run as it will, it gives room to bumper sticker theology and lies.

Our minds are like our bodies. They must be fed, exercised, and restrained from overindulging.

In the midst of another episode of allowing my mind to run untethered, shaking my fist at my circumstances, I asked God *why me?* It was then I realized my asking implied I didn't think my family should have to suffer like this, to lose a son. So whose did I think should? There is no answer. No one should have to lose a child. There is a long list of cruelties no one should have to endure. No one can be a good enough person to keep all pain away. It just doesn't work that way. Sadly, it is common to lose a child in a car accident. It happens every single day. Sickness, death, and broken relationships are a heartbreaking but inevitable part of living.

To dwell in thoughts of *why me, why us, why my Dan* keeps me from accepting the right answer—which is simply because my family is not immune to tragedy.

We live in a fragile world with flawed people. There is no why that will make it all right.

What can be done? What must be done is to capture the thoughts that torment the soul. Renew your mind. Train your thoughts to build your life rather than tear it into more pieces. It's important to understand you have already created thought patterns within your mind that your conscience travels daily. It's paved by your unconscious mind. Just like driving down the highway at seventy miles an hour, you can easily miss the signs and scenes along the way, so too will you miss the whispers of your superconscious, your soul. It is a voice that will never demand its way.

It is at this point when trusting in the Lord of creation comes into play and healing begins. You can replay the hurts in your life like a ticker at the bottom of the six o'clock news. You can choose to live in the land of instant replay with all of its bruises,

betrayals, and unfairness. Or you can envision a different life. You can take the fire that has burned you so deeply and draw from it the qualities only fire can bring. But first you have to change the fire into fuel, and that begins within your thought processes and patterns.

> For though we live in the world, we do not wage war as the world does. The weapons we fight with are not the weapons of the world. On the contrary, they have divine power to demolish strongholds. We demolish arguments and every pretension that sets itself up against the knowledge of God, and we take captive every thought to make it obedient to Christ.
>
> —2 Corinthians 10:3–5

What is the knowledge of God? The best place to begin is with the knowledge that God loves you and wants you to live a full and prosperous life. A life of healing and grace. It is not His will that you stay trapped within pain or grief for the rest of your life.

You have been put on the earth for a unique purpose. Your purpose is written on your soul for only you to read. It is there. But it is up to you to take captive every thought that will make itself higher than the knowledge of God. Any thought that attempts to keep you in turmoil must be captured. All thoughts that wrestle with the truth and try to pin it to the mat of despair must be brought into submission.

When you learn to be still before God and take captive the thoughts that plague you, His voice will rise within.

## Fragments of Reflection

What is your default setting? Are you naturally inclined to be a more positive person, or do you tend to overreact? When something bad

happens, is your first thought, "Why me?" or "What did I do to deserve this?"

The questions you ask yourself are almost as important as the answers.

"Why *my* family?" "Why did this happen to us?" "Why did this happen to me?" Do you allow your mind to take you places you don't want to go?

If you are going to ask yourself *why me*, you also have to ask yourself *why not. What makes my family exempt from heartache and tragedy?*

## Be Still

Let's take this just a little further. Take three deep breaths, letting them out slowly. Allow the Holy Spirit to lead your thoughts. When you do, are you noticing that you have to fight the random or rogue thoughts that don't bring you peace? It can be as simple as telling you that you are wasting your time. That you have other things to do that are far more important than being still before the Lord. That is a thought that exalts itself above God. Learn to listen closely to the thoughts that come in over the next few minutes.

## Deals with God

Restless grief wouldn't allow me to sit still in my chair that Sunday morning. Images of my son and all I'd lost with him pulled away in my mind like scenes in a rearview mirror. As I paced back and forth, crying out and pouring my sorrow into the heavens, I told God I had lost my will to live another day. The pain was more than I could bear.

Without an audible voice, deep in my spirit, I felt Him say, "What if I gave you what you are asking for? If I remove him from

My presence right now and give him back to you—would you do it?" A new wave of emotion swept over me, and instantly I knew my answer. If I truly love my son I had to say no. I must say *keep him. Keep him, Father, for eternity, and wrap him in a love that has no boundaries. Protect him, and one day, take me to him.* It was then I realized what I really want is for all my children to one day be with him and with my God and Savior. When my work is done here, I want to see his face again.

In 1 Kings 3:16–28 we learn of the wisdom of King Solomon. Two women living in the same household had given birth. Soon after, as they each lay in bed that night with their own infant, tragedy struck. One of the mothers rolled over her baby, and before she knew what was happening, the weight of her own body killed the newborn. The distraught mother then saw the other woman with her baby sleeping peacefully. In a desperate move, she took the other woman's infant and slipped her own dead baby in its place.

Upon awakening, the mother of the living newborn saw the dead child and immediately recognized the baby was not hers. As you can only imagine, a fierce fight broke out between the two mothers. The women were brought before King Solomon, each telling their version of the story. Both women claimed the living child as their own.

After listening to their pleas, the king called for his sword and ordered the infant to be brought to him. The king then commanded the baby to be sliced in half. Each woman would be granted her own half of the child. Hearing this, the real mother cried out in despair and begged the king not to kill her baby. Instead she pleaded to let the other woman have him. She would rather see him go to another than allow him to die. At the same time, the other mother was content with the king's solution—and agreed. Immediately the king recognized the real mother by her sacrificial love. She would

pay any price to spare her child suffering—even if it meant losing him.

I felt like the woman who couldn't bear having her child cut in half, but I was acting like the woman who was fine with sacrificing the baby. But I realized that even given the choice, I could no more take my son out of the presence of God just so he can live in my presence and heal my broken heart than I could allow him to be cut in half. Our children were created as eternal souls for intimate communion with a God who loves them more than we are capable of. I can accept that. But if I do, I must make the resolve to not grieve that end. Each one of us will one day be severed from the people who love us.

This realization was a turning point for me. Although my son is not with me, he is where I one day want to be—together with Him. The immense pain I'm feeling is my wounded mother's heart. That is what needs tending to.

I stopped allowing the thought that I could not bear the pain. The thought that I wanted to die rather than live in this agony had to be replaced with the truth of Scripture. For me to accept the peace God was offering came when I took control of how I choose to view this loss. One thought pattern was nothing short of the decision to not live with the pain. That was the easy choice. I wanted to think about him until it hurt. The pain of grief washing over me was all I had left of him. And yet it was more than I could bear. It brought me to a place where I could no longer take any pleasure in anything in my life. I didn't want to live anymore. The shift of my thinking was the belief he is happy. There is a heaven. It is where we are complete and fully know what it's like to feel joy without pain. Being in the presence of the God of love is what we were created for. How could I take that from him? Just so my mother's heart could be whole again? Bringing him home from the presence of God would not be for his benefit—it would be for mine. That thought shift saved me.

Considering that my thought patterns would neither bring my son home nor change my circumstances—nothing would change the past—what did change with my decision to think differently? My thought shift was about how he would feel. About the fact that I needed to be able to join him one day in heaven. One thought brought life, the other led me on a path to death and defeat. Capturing my thoughts and bringing them into the obedience of what I chose to dwell on—the promises and knowledge of God— didn't change the past, but it did completely change my future.

You and you alone have the ability to change your thoughts.

Just like we had to dispel the bumper sticker theology that maligns the character of God, we have to gain control of a wandering mind.

What we often refer to as negative thoughts are actually poisonous. It's misleading to refer to thoughts as simply positive or negative. Toxic thoughts can do as much damage as small doses of poison. We don't even have to make up our own. It's all too common for someone to say something that is extremely hurtful and wrong—and yet we tuck it away and hold on to it.

Why do we hold on to something that brings us pain? Oftentimes we let it live in our heart and allow it to poke its deadly head out when we are feeling bad.

The thought that I could not live with the pain of losing my son was a slow poison that, had I allowed it to continue, would have ended in my death. But you don't have to be that far in despair to be a victim of your own toxic thoughts.

Another thought I allowed to poison my mind was that it was my fault my son died. He asked me—no, he begged me—to go with us to the hospital. The guilt that I don't remember my last words to him, the prayer he asked us to pray together before I left, all were seeded in my mind that I alone was responsible for his death. Because I could have stopped it. This tragedy could have

been stopped by me had I not been so concerned about the cost of feeding him out of vending machines or dealing with his boredom. My concerns were not worth his life.

It was just a few months later when I learned several members of my family had the same feelings, the same toxic thoughts going through our minds. My daughter, Jami, believed it was her fault for delaying them—which put them at the intersection at the exact time the accident would occur. My son, Chris, felt guilty because he had bought the truck Tommy was driving. Tommy carried the most weight because he was driving and was tormented at the thought of being responsible for his little brother's death. None of these thoughts were true. None of them came from God. These were thoughts that exalted themselves above the truth.

Have you had these kinds of thoughts? Maybe it's something one of your parents said to you. Or your spouse. These poisonous words lodge into your mind, sink into your soul, and kill parts of your life. One simple example of a toxic thought I held on to for many years was told to me by my mom: "You never finish anything you start." I believed her. So every time I wanted to take on something new, I heard her voice in the back of my mind. For years, it brought guilt and shame. Then one day I heard that same voice and thought—*wait, that's not true at all. There are a lot of things I have completed. Some things I've started and realized I never should have begun in the first place—and jumped ship.* Where did we get the idea that everything that is started must be finished? That by leaving something unfinished is a character flaw? Sometimes it's just good common sense. It was a small belief about myself that influenced a lot of my decisions and the course of my life. Large and small, toxic thoughts are still poisonous.

You have to fight these thoughts with truth. The truth is life. It is the only antidote for a poisonous thought—whether you put it there or someone else. It doesn't matter if you have held on to it

since childhood or it is still fresh. Douse it with truth. Sometimes it's those small doses of poison over long periods of time that do the most damage. They might not make you want to give up on life, but they can certainly keep you from living the life God has planned for you.

This simple exercise in honesty will take some bravery. Facing the truth is often much harder than believing the lie.

Take a pen and paper—preferably an index card. But if you don't have one, any piece of paper will suffice. Now, write down the ugly thought. Sprawl it out on paper in all its naked glory—just like you are hearing it in your head. The one you may have never uttered out loud because it's too painful; instead, you just let it take up residence in your mind and pollute your spirit.

Mine went something like this: *You could have stopped this. God gave you the chance to make it not happen, and you ignored it. You were too busy to pay attention—just like you always are. You were selfish and hurried. This is your fault. You could have prevented Danny's death.*

Write the truth on the flip side.

*I could not have stopped this from happening. I left my son in the safest place I could. At home playing with my grandson. God did not give me a chance to make it not happen. That is a lie. I'm often too busy. My busyness did not cause this accident. I am often selfish. My selfishness did not cause his death. I was given the choice to take him with me or have him stay home with his family and enjoy his day. I was not given the choice to have him go with me or allow him to die in a car accident. This was not my fault. This was a tragedy that happens to many people every year. I wish this didn't happen to my son, my family, to me. But it did.*

Once these words are out of your mind and on paper, the stain of the poison can be left there. Tears flowed with those words. But healing came with the truth that followed. Those words are truth. When the lies come, and the thoughts that begin to scroll at the bottom of your mind's screen, pull out the new script. Read it out

loud. There is power in the truth, and there is even more power when you utter it with your own words.

Now it's your turn.

Sort through your thoughts as they come in. Do they stand up to what you know is true? Do they bring peace? Do they bring joy?

It is so easy to believe a lie of our own making. The thought that the accident was my fault was a lie. Yes, perhaps had I allowed him to go with us, he would still be with us. However, "It is my fault; I should have allowed him to come with us," is an imagination that lifts itself above the most high God. Because God wants him? No. Because it is simply not the truth. What is the truth is that the accident happened, and he is gone. There is nothing in my power to change that. The only power I have is to not allow my mind to blame me for the death of my son. For me to take the blame, or anyone else connected with the event other than the man who hit them, is not the will of God.

> In addition to all this, take up the shield of faith, with which you can extinguish all the flaming arrows of the evil one.
>
> —Ephesians 6:16

We all live two lives. The one we live inside our heads and the one we have to fit into. We have our inner thoughts and the world we have to fit into each day.

Thoughts come in like a flood. But we have the ability to capture and hold them or to hold on to them and make them a physical part of our being. Our thoughts are real. They can change the course of your life. They can bring destruction or they can bring life, healing, and God's goodness into your life.

## Prayer

*F*ather God, I come to You in Jesus' name. Lord, You know my inner thoughts. You know my hiding places. You know my pain. Only You know how badly I hurt. Fix me, Lord. Heal my heart. Show me the way to Your perfect healing and peace. I don't want to listen to my own imaginings any more. I need to hear from You. Renew my mind. Teach me, Lord, to recognize the voice of the enemy of my soul. Teach me to run to the sound of Your voice. I know You have good plans for me. Father God, create in me a new heart. Teach me Your ways. I give this time to You, and I ask you, Father God, to show me what You would have me do today. Fill me with Your Spirit. I want to know You.

# Chapter 6

# His Mercies Are New Every Morning

In the morning, LORD, you hear my voice; in the morning
I lay my requests before you and wait expectantly.

—Psalm 5:3

It started like every other day. The sun rose. Although I didn't take time to see it. Our morning routines were running full speed. Breakfast, chaos, chores, lost shoes, and the hurried rush for the door. I've often reflected on how typical that day started. And how extraordinarily devastating it ended. It began mundane and routine. There was no warning that day would be the end of the life we knew. Or that it would be the last sunrise of my son's life.

No matter what we plan, we simply can't know what the day will bring. It may blossom with new life or shatter at your feet. This we can know: every morning we can celebrate the gift of His new mercies. We can stand in awe of the sunrise and breathe deeply. Inhale and exhale the holy name of the Living God.

Have you seen the sunrise lately?

I understand you have been a bit preoccupied. Most of the time we all are. Good times or bad, there are hundreds of reasons we miss the simple beauty of a sunrise.

Sleepless nights with my babies kept me from them for years. I had to make it an actual written goal to get up early enough to see a sunrise at one point in my life. Full disclosure: my goal was not to see a sunrise. My goal was to survive the day filled with small children and the demands of young motherhood. I was looking for a way to keep my sanity and stretch the hours in my day. When I began to get up before or with the sun, I discovered the beauty and the restorative power of the sunrise hours.

Those hours are a refuge.

At first it was stolen time for me before the house erupted with toddlers. After the accident, it was where I could hear my spirit cry out to my God. It was then I could hear His voice above the pain.

> I have been deprived of peace; I have forgotten what prosperity is. So I say, "My splendor is gone and all that I had hoped from the LORD." . . . I well remember them, and my soul is downcast within me. Yet this I call to mind and therefore I have hope: Because of the LORD's great love we are not consumed, for his compassions never fail. They are new every morning; great is your faithfulness. I say to myself, "The LORD is my portion; therefore I will wait for him." The LORD is good to those whose hope is in him, to the one who seeks him
>
> —Lamentations 3:17–25

His mercies are new every unique, beautiful, sun-bursting morning. His love for you is faithful. It follows you into the darkest night. Each morning brings with it the new hope of the beginning of another day. Because we have an inheritance in our Creator. When you face your darkest days, give yourself the gift of rising early enough to see the sunrise. To wake up and see its beauty and

realize it is a celebration of His mercies renewed, and allow it to breathe hope into your spirit.

Monday. Sunrise. The New Year. Your birthday. A blank sheet of paper. These are just a few of the countless ways our Creator presents us with new beginnings. Each one is a unique, clean canvas coated with a high gloss of hope waiting for you to sketch your life. Hope is the expectation that something will happen—and something always does. Every day starts the same: with a sunrise, and with it there is new hope.

The phrase, "It's always darkest before the dawn," is the epitome of a platitude, of a remark with moral intent that has been used too often. Sadly, it's been said so often it loses its meaning. Another little piece of ageless wisdom goes unnoticed. It holds a hope-filled truth both physically and spiritually. Just when the night is at its deepest darkness, and it feels endless, the sun peeks out over the horizon. That moment is framed with a painted sky that trumpets its arrival as though heaven itself were celebrating.

Watching the sunrise is more than just a nice thought.

Let's face it. You are going to have to wake up in the morning. Like it or not. The sun will rise in the morning. What will you do with it? Allow it to slip by unnoticed? And in its stead have an alarm jolt you out of deep sleep? Pull yourself out of bed to face another day? Another day in a world you don't want? It doesn't have to be that way.

You have a morning routine. We all do whether you are aware of it or not. I bet if I asked you what you do when you wake up you could tell me. Maybe you could even tell me within minutes the time you wake up each morning. The first step in creating a new world is to greet the day head-on.

Has it been hard to hear God's voice?

Maybe you're not sure if you have ever heard it. Now is the time you need to hear it most.

As we talked about in the second chapter, the simple, daily routines of our lives create a comfortable familiarity. We create daily rituals and form habits. Sometimes they fall into place without us even realizing it's happening, like our morning routine. Now is the time to be intentional about creating new habits, and in doing so you will create a new normal.

June 3, 2008, is the date that splits my life. Before that day, my life evolved in the natural course of time and maturing. Events like getting married, job changes, and children gradually altered my day and routine. After that day, my routine was violently changed. Not just because of the event that changed it but because I was unable to function mentally and physically. When I decided I could not live in that state of pain or go back to my life before, I determined in my heart that I would recreate my daily life—rather than letting sorrow create it for me. You can create a new normal. When you can't change your circumstances you most certainly can determine how they will impact you.

You too have a choice to create a new normal. You are in this new world where your forest has been ravished by the flames. In that floor of ash there are seeds buried deep the fire has broken free. You might not see them there yet. Nevertheless they are alive. There is fresh light that will stream through where there once was darkness that will bring new life. Why not start with greeting the new day along with heaven's celebration of the sunrise?

You are facing a major life change, and you need restorative sleep. Your body, as much as your inner self, is going through significant stress. A full night's sleep is the first step of preparing for a good tomorrow. So I'm not saying to cut your sleep to see a sunrise.

If waking up in time to see the sunrise would disrupt your ability to get a full night's rest, think about your nightly routine. What is an ideal time for you to go to bed and wake up naturally—before your alarm? The best way to find the answer to that

question is to think about when you go to bed the night before you know you can sleep in—what time do you wake up? Count the hours as best as you can remember the last time that happened, and you will have your ideal number of sleep hours. It may be more now. You and your body are going through this life change together. Don't dismiss its impact on your physical health. Your local weather station or app will have the time of the next day's sunrise. Count back the hours you need to sleep, and you have your new bedtime.

Here's the thing. You may very well feel like it's too early to go to bed. Most likely it is for the first day. But this is the time you are working toward. The goal is to go to bed and wake up on your own, just before the sunrise, and before your alarm goes off. Your alarm should be a safety net, not what actually wakes you up. If it does the first day that's fine. Your new bedtime will be much more welcomed after your first day. Consistency will teach your body when to wake refreshed, and your soul will love being greeted by God's idea of a new beginning.

Quick overview:

- Pray before you go to sleep: Ask the Holy Spirit to wake you fully rested just before sunrise.
- Get up immediately: Set out the next day's outfit the night before so you don't have to think about it. Include that in your nightly routine.
- Be realistic about the time you need: If you need coffee or a few extra minutes in the bathroom to function, be sure to factor that into your wake-up time.
- Thank the Lord for another day: Try praying, "Oh Lord, in the morning You hear my voice; You satisfy me with Your steadfast love. I will rejoice and be glad."

When you see the sunrise, let the holiest name in the universe slip from your lips. Breathe the name of God.

Genesis tells us God made mankind from the dust of the earth. Then He breathed His own breath into him, giving him the breath of life. At that moment, we became living beings made in the image of God.

God spoke to Moses in the form of a burning bush, telling him that He had heard the cry of His people, and He was sending Moses to free the Israelites from their captivity. Moses was probably trying to figure out how he was going to explain that a burning bush talked to him when he said, "Suppose I go to the Israelites and say to them, 'The God of your fathers has sent me to you,' and they ask me, 'What is his name?' Then what shall I tell them?" (Exodus 3:13). God answered, "*Ehiyeh asher Ehiyeh.*" This is often translated in English as "I AM WHO I AM" (v. 14). Some scholars believe it is much more than that. It is not only I *am* but also, "I was who I was. I am who I will be." This has also been interpreted as *Adonai.* God is called by many, many names throughout the Bible. But what exactly does God call Himself? This is how Rabbi Lawrence Kushner explains the name of the living God:

> **The letters of the Name of God in Hebrew are *yod, hay, vav,* and *hay.* They are frequently mispronounced as "Yahveh." But in truth they are unutterable. Not because of the holiness they evoke, but because they are all vowels and you cannot pronounce all the vowels at once without risking respiratory injury. This word is the sound of breathing. The holiest Name in the world, the Name of the Creator, is the sound of your own breathing. That these letters are unpronounceable is no accident.**

Let that soak in for just a moment. The first breath you took as a newborn was an inhale, and your last breath on this earth will be an exhale. The name of God. The Alpha and the Omega, the beginning and the end. Our lives begin with His name on our lips, and it will be the last sound that slips from us. Every living creature utters the name of the Creator. His name is life itself.

## Fragments of Reflection

In Mark 1:35 we find that Jesus rose before the sun and found a place to pray: "Very early in the morning, while it was still dark, Jesus got up, left the house and went off to a solitary place, where he prayed." Moses, as recorded in the Book of Psalms, wrote, "Satisfy us in the morning with your unfailing love, that we may sing for joy and be glad all our days" (Psalm 90:14).

Jesus knew that quiet time alone before the sun rose, before the demands of life hit, was the time to address the God of creation. Perhaps He too needed to feel and see the celebration of the sunrise.

Do you have a special time each day that you have set aside to reflect, to think, to pray, and restore yourself? If not, what is holding you back from setting aside time to see the sunrise and welcome a new day along with creation? Consider committing to adding this to your daily routine for the next twenty-one days.

## Be Still

The simple act that we do breathe every minute of our day is really quite profound when you stop and really think about it. We aren't trusted to remember to fill our lungs on our own will. Instead it's on autopilot. Yet when we slow down and purposely inhale and exhale while acknowledging the name of the living God, it can change your life.

Throughout this book, as you come across words that strike your heart, stop and breathe the name of your heavenly Father.

- Close your eyes.
- As you inhale deeply, lift your head toward heaven in praise.
- As you exhale, slowly lower your head in humble thankfulness.
- Do this several times until you feel the peace come in.

Don't be afraid to hold your breath briefly between your inhaling and exhaling. As long as you are not doing it fast or begin to feel dizzy, you are bringing life-giving oxygen into your mind, body, and spirit. In this state, you will often feel the prayers you need to pray bubble up inside.

Are you the kind of person who sees the built-in opportunities God designed in our lives for do-overs, course correction, and just plain fresh starts? Or do you feel a painful pinch in your chest reminding you of past failure? Does the very thought of setting goals or making plans for the future intimidate you or make you feel small? Whether you are a natural list maker or a roll-with-the-punches kind-of-gal, right now it's hard to see tomorrow. When life takes a hard turn away from the future you envisioned, it's easy to believe the future isn't really ours to plan.

In politics there's a saying, "Never let a good crisis go to waste." I know. It's sad but true. Whenever there is a tragedy, politicians know it is a prime time to make changes—often extreme policies that wouldn't have been tolerated before. It's two parts opportunistic and one part problem solving. The will to fight deflates. The resolve before the crisis was to maintain the status quo. Then, after something drastic has happened, something just as drastic can take place. While this is more often than not an exploitation of human nature, it is real.

It also is true on a personal level. When life shatters, it's an opportunity to garner the strength to lay new foundations. If you

want to not only survive this time in your life but you want to thrive, you can. You can use this fire to refine you. It does not have to define you.

In the days, months, and years after the accident, I slowly realized my personality had changed. Before, it wasn't hard to see me as an extrovert. When my heart was torn from my chest, it turned my personality inside out along with it.

Although I've spent decades as a writer, I've not been someone who journals. The thought of journaling was always a bit overwhelming to me. However that has never stopped me from loving (and buying) beautiful journals. I love blank pages, watercolor paper, and all visual invitations to creativity.

One such journal caught my eye. It was a beautiful hand-stamped, Italian leather-bound journal. It was light tan in color with roses and beautiful French lettering burned into it. I had to have it. However every time I would open it to write, I couldn't figure out what to write. Such a beautiful book needed to have an equally beautiful inside. This created a lot of barriers. There was my handwriting. Then, of course, there was the issue of the possibility of a misspelled word—no autocorrect with a pen. These two issues caused my perfectionist tendencies to flare. What could I possibly fill this elegant book with that was befitting?

The answer eluded me.

So for three years it sat on my desk. With its stunning beauty on the outside and blank pages on the inside. I admired it from afar.

In *The Artist's Way*, Julia Cameron first introduced me to the concept of stream-of-consciousness writing. It differs from traditional journaling in several ways. She recommends artists use this exercise to free themselves from creative blocks. That is just the beginning.

Stream-of-consciousness writing clears the way to hear the voice of the Father. It removes the sound barrier between your

noisy mind and your spirit. We all have accumulated a lifetime of mental clutter—cultivating the habit of taking out your mental trash every morning will help you capture your thoughts and renew your mind.

Remember, the best day always starts the night before. Set out whatever you may need—pen, journal, change of clothes, etc. Put it in a comfortable place, wherever you plan to write. Before you go to sleep tell yourself the plan: I will sleep well tonight. When I wake up, I will greet the sunrise, and then I will go to my journal and write. As soon as you have done the most pressing early morning routines (mine includes pouring a cup of coffee or tea), sit down to write. Try to make it within the first thirty minutes of waking up. Write three pages in longhand, preferably with a pen.

Write whatever your mind drudges up. Whether it is how bad the coffee is, how stiff your neck feels, or your deteriorating penmanship (I have a lot of pages on that), it doesn't matter. The point is to empty your mind of every bit of clutter you have accumulated and stored overnight. It might be a conversation that is replaying in your head. Maybe it's the perfect rendition of what you wish you'd said to someone, and now it's too late. Or perhaps it's a conversation you need to have but haven't been able to formulate the words. Instead they've been floating in the back of your mind hovering over you throughout the day. Let them go by spilling them into the privacy of your pages. Fill the paper with your looming tasks. It doesn't matter. This is a mental dumping ground. You are writing for no one's eyes but your own. It's not meant to be shared or left for posterity. While it seems to be no more than written babble at first, don't let its humble beginnings fool you into dismissing the power it has to change your life.

Your first sentences will be written purely from your conscious mind. Remember, it is the one you are most aware of. It also has the loudest voice. As you write, you will clear out the mundane

thoughts that obscure and hide the issues of the heart. Soon you will find a shift. For me, it usually happens as I round the second page and head to the top of page three. You're no longer thinking about dinner plans but have transcended into another area of your mind that can communicate from your spirit. Many times I will ask a question only to have the answer flow out of my fingertips and find its way to the paper. I pray in these pages, ask burning questions, and receive answers. Writing in these pages will give you the ability to dig deep into your spirit, where you are more fully yourself. When the influence of the carnal mind is silenced, your classroom for learning to listen for the voice of your Heavenly Father is opened.

As I was searching for something to write in, I spotted my beautiful rose journal. It was then it occurred to me that my untouched journal was the perfect place to write my daily reflection pages. It was a symbol of me—and perhaps you as well. The beautiful outside represents my attempt at a polished appearance. It tells the world around me, *I'm okay.* But inside is another story. Inside I'm a tangled mess of emotions, dreams, and fears. Inside my conscious mind gives my subconscious a voice and breaks the cluttered barrier between my soul and my Creator.

Within these pages, my knotted thoughts begin to loosen. And the lines of communication begin to flow. There is one thing I noticed very early on that I want you to be aware of. There are times when I begin to write, not every time but every now and then, that I hear a voice in the back of my mind. It sounds like my conscience. *You are wasting time. Look at the babble you just wrote. Really? Why are you sitting here writing nonsense when you have so much work to do?* I counter the thought. *No. I committed to doing three pages daily. I will do three full pages.* Shortly after, I will head into my third page, and the answer to a question I have been struggling with will pour from my pen. Such peace floods my soul. It is the

breakthrough I've been looking for—the answer to a problem or a prayer. In short, it brings clarity to a situation. Closing my book, I will marvel at how close I came to not having the breakthrough I so desperately needed. This has happened more than once. Now I'm familiar with that voice. I see it as more of a checkered flag. When I hear that voice of discouragement, I know I am on the right path, and there is something I need, something good, waiting for me. When I hear that wee voice in the back of my head trying to convince me to turn back, I actually get a bit excited. It is the surest sign there are good things in store for me the enemy of my soul does not want me to have.

Where do you begin? What do you write about? Anything. There are no rules other than to write as soon as possible after rising. Write for either three pages or thirty minutes. I have done both. As I need to get my day going, and I am more productive when I am under a time restraint, I write for thirty minutes, which is almost always three pages. On the weekends, I allow my mind more time to wander. Usually this leads to more than three pages, but I always come away feeling filled and restored. Get up a little earlier if you must. But make it a priority to begin this simple habit. We will build on it in the coming chapters. Commit to doing this daily for twenty-one days. When that tiny voice of condemnation starts to taunt you, you can say, "Maybe so, but I have made a commitment."

In *The War of Art*, author Steven Pressfield explains, "Most of us have two lives. The life we live and the unlived life within us. Between these two stands Resistance." Writing each morning, upon waking, will help you to slay the resistance that stands between the life you long to live and the one you are living. Resistance is that voice saying you have too much to do to be writing nonsense. It will appeal to your sense of responsibility and flood your conscious mind with doubt. Recognize it, call it by name, and tell it to step aside. Your subconscious needs to surface, and your soul needs to

hear from the Holy Spirit. We will take a closer look at the power of resistance in a later chapter.

You might be thinking, *what are you talking about? You don't understand. My life is shattered. The life I want to live died and along with it hope of a future.* I absolutely understand that. But there is still air in your lungs. We are not meant to live our entire lives in pain. We were not created to live without hope or peace. You have a life that is yet to be fulfilled. That life is written on your heart. It's there. You know it is. You have caught glimpses of it but allowed it to become buried under a pile of mental clutter or perhaps you feel trapped in a life you believe you can't change.

## Prayer

Father, You know my innermost thoughts and dreams. And I know You put many of them there. The cares of this world have entangled my heart so deeply I'm not always sure what is me and what is of You. Help me, Father, to loosen the cares of this world from my heart and mind. The mental clutter I carry is sometimes more than I can bear alone. My mind tells me stories that are not always true. I want to hear Your voice. I need to feel Your peace within my mind and spirit. I have so many questions only You can answer. I give it all to You. Lead me to You in a new and fresh way.

## Chapter 7

# While We Draw Up Plans

The house was quiet. The kids were bathed, tucked in, and finally asleep. At least that's what Kat hoped. She tiptoed down the hall and into the kitchen. The looming stack of dinner dishes piled next to the sink looked more like a refuge than a chore. She slipped her hands into the warm suds. Thoughts came and drifted away like the bubbles riding on the dishwater below. *So this is my life*, the young mother thought. *Three kids and housework. Trapped.* Just as Kat began to accept her fate, she heard the sound of cold metal sliding up and down the shotgun behind her. Kat froze. With her heart pounding in her throat, she tried to swallow. A current of fear shot through her veins. The countless threats to kill her echoed throughout her body paralyzing her. She felt a warm, slow trickle down her inner thigh. As the urine began to pool on the kitchen floor around her bare feet, she heard her husband erupt with laughter. "Not today, Kat," he said, as he stumbled back into the living room howling at his own cleverness.

A few months later, Kat gathered the strength to leave her violent husband. When she went to a lawyer to file for divorce, he asked her to write down her grievances and bring them back to him. She knew it was too dangerous to write something like

this where her husband could see it. Kat snuck away to a local motel room. She locked herself in the small dark room for a day and a half. Sitting at the desk under a single-bulb lamp, Kat poured out the painful details of her thirteen-year marriage. Thirty-six tear-stained pages later she was emotionally drained and mentally exhausted. Looking at what she had written, the gravity of her life fell on her with a weight she could hardly bear. There it was. The ugly truth. There were no lies she could tell herself to make this any better. It was too much. She couldn't go through with a divorce. It would be too hard. She would lose her children, and possibly her life, just like he always said she would.

He had convinced her she was the problem and the cause of his behavior. She was his problem. Not the other way around. Without her in the way he would be fine and the kids would be happy. Once again Kat slid into believing his distorted lies. Gazing down at the stack of paper filled with her shaky handwriting she made a decision. The only way to escape was to end her life. Pills and alcohol would numb the pain. That should do the trick. She could quietly slip away to peaceful sleep forever. It would be over. Next step would be to leave her hideout and find someone who would give her the pills.

As she walked toward the door, Kat caught a glimpse of a Gideon Bible sitting on the nightstand. The very sight of the Bible made all the anger she had pressed down deep erupt in a fury. She threw that fat green book as hard as she could. It hit the wall and landed open on the bed. For an hour-long minute, Kat stared at the exposed pages from across the room. Like a bug drawn to light, she had to see what it said.

Kat read the first line she saw, "I can do all things through Christ which strengtheneth me" (Philippians 4:13 KJV).

"Seriously? Are you kidding me right now?" She yelled at the book.

Kat picked the book up again and flung it even harder at the opposite end of the room. Only this time it was toward the door. That meant she had to pass it before she could walk out. Taking slow deliberate steps towards the door, and the Bible, she stopped and hovered over the book. Once again, it landed face up and pages lying flat. It felt like a personal invitation to read a message. Carefully picking up the Bible, she read, "I can do all things through Christ which strengtheneth me."

This time the words sunk into her tattered spirit. Kat dropped to the floor. With the Bible in her lap, she let the words penetrate her soul as she cried. With a renewed surrender to Christ came a different kind of courage. Kat chose to live and be set free.

Although Kat had reached out to Jesus as a little girl, the life she stepped into as a young woman made the voice of God inaudible to her. He didn't forget her. When she couldn't reach out to Him, He reached down to her and answered the question that burned in her heart. *Can I change my life?* Her reasoning mind said no. The only answer was suicide. Yet when she allowed herself to face the truth and accept the hope of Scripture into her spirit, it changed the trajectory of her life in an instant.

Not once did Kat as a young girl plan to marry an abusive man.

We are often told that planning your life, setting goals, chasing your dreams, is the best way to achieve happiness. We plan for college; we plan for a vacation. It is part of our nature. We all exercise it to one degree or another. So why is it that we fail so miserably so often at it? Why is it that some people fall into all those things seemingly effortlessly? Why is it that those plans, goals, and dreams are so easily shattered in the blink of an eye?

# Control Is an Illusion

The infinite amount of activity that swirls around us is more than we can fathom. Both in the spiritual world and the physical. Not to mention the people who come and go in our lives. There is only one constant—the steadfast love of the God who created you will not leave you.

The only control you have is over your mind and spirit. You are made in the image of a living God. You have the ability to create your life. Your inner life. In reality, that is what is shattered. How you choose to respond is within your control.

Your mind has the ability to turn thoughts into reality. You can create and cast a vision for your life and pursue it. Or you can follow your intuition and create the life God envisioned for you. The one He has planned for you.

There is a distinct difference.

Visualizing is a mental exercise of the conscious, reasoning mind. You could say it is your will's imagination. It's not hard to visualize yourself in that new house or sunning on a beach. Like putting cutout dresses on a paper doll, you can visualize your life in many different scenarios. This, depending on your basic outlook, can also work against you. You can visualize yourself out of work, missing your flight, or learning your children are sick. These are imaginings of the conscious mind. You are controlling it. This is what we must capture and renew. You can accept or reject thoughts, creating your own thought patterns.

Vision, on the other hand, is a spiritual pursuit. It is your intuition. It is what you just know. A vision is not governed by reason, sight, or your will. It is divine in nature. It is seen as it is projected onto your soul. If you listen for it, it can come as a knowing. There are some things you just know. We don't always

talk about it, usually because our reasoning mind scolds us when we do. It tells you that you could be wrong and you would look silly to talk about things like that. If you listen to your reasoning mind enough, you learn to stifle and mistrust your instincts. It takes a deliberate decision to quiet your reasoning mind and trust your instincts or intuition.

Intuition is your soul speaking to you. It often knows things your reasoning mind can't yet grasp until it has already happened. Too often we allow our reasoning mind to take the lead. Have you ever gone against your intuitive feelings only to regret it later? Of course you have. Everyone has at one time or another. Our reasoning mind is not always right, although it seems that is what we are taught to believe.

The most common example of raw intuition is found in new mothers. With the birth of a baby comes a strong mother's intuition. Most new mothers have to learn to trust their instincts when it comes to their children. Countless times I have thought *check that toddler's mouth* only to retrieve a potentially deadly object. It's the same way with learning to trust your intuition for your life.

Your next step to putting the pieces together is to learn to read the love letter from your maker. He placed it deep within you. The only reason you haven't been able to read it is that you have given strength to other areas of your life. That's not necessarily a bad thing. It just is. The reasoning mind is what you spent years educating. Your subconscious or unconscious lies quietly transcribing every moment of your life by emotion whispering to your spirit.

## Finding the Light

While I listened to a friend talk about his struggle to find God's plan for his life—what job he should take and where he should

live—I got a word picture in my mind of what his faith looked like. It seemed to me he was mentally going into a dark mansion with many rooms and long hallways. He would stumble into one room looking for God's plan as though it were the light switch. If he could just feel around in the dark long enough to find the light switch and flip it on—*ta-dah!*—everything would be clear and in plain sight. There would be no more stumbling in the dark. No more falling down or tripping over mistakes. One just had to feel his way into each room of his life and find the God-switch and turn on His plan. That would be the key to a happy and successful life—complete without failure or tragedy. That is, once God's plan was found and flipped on. It would outshine all the darkness and light the way to the problem-free path in every area.

I can tell you where God's plans for your life are, but you will need Him to help you read them.

The plans He has for you are not hidden from you in a dark room. They are painted on the canvas of your heart. Your soul can see it. When you quiet your mind, you can feel it. There is a vision inside you of what your life can be. The God of the universe had a divine idea when He created you. In spite of what life has looked like up to this minute, His idea is still the most beautiful part of your puzzle. It's the part of the picture that can't be seen by the reasoning mind. Because the conscious, or carnal mind, can only see reason and substance before it—what it can see, feel, and calculate is only real. But the soul speaks with the Holy Spirit and sees what you were created to become. It knows your unique part to play in creation. Once you grasp who you were created to be, to do, or to love, what wonderfully unique place you hold—that no other person on the earth can take your place—that is the divine reason of life. Your life. No matter what you face, this vision will give your life the meaning and purpose to not only survive but to find joy.

In all of us, there is the life we are living, and then there is the internal life we long to live. The space between the two is where we so easily get lost. That is when we find ourselves searching in the dark, feeling our way along the walls, looking for the light switch, or praying with our arms crossed and stomping our foot. The room my friend was looking for does not exist. He mistakenly believed if he understood God's will then it would be an easy life from then on. It is possible to be completely within God's will and still have tragedy strike. To be fully in God's will is to fully trust Him with your life.

## When God Laughs

Gerry knew what she was created to do from the time she was just twelve years old. She knew she was called into ministry. But it just never really seemed to happen. She came close. She worked in her church and always had the heart of a compassionate teacher. Although she knew she was called, Gerry was also planning her life along with her husband Don.

The time had finally come. After a lifetime of work and planning, Don was ready to retire. Don and Gerry had plans, big plans. A new home that would serve mainly as their home base as they traveled and lived what the couple considered the "high life." They had planned and saved for this time of their life for longer than they could remember. But first Don needed to get rid of this irritating scratchy throat.

In early March the couple celebrated the beginning of this new life of retirement. They were happy and hopeful. It felt as though they were finally going to be able to enjoy the life they so carefully planned. The life they had been waiting for and dreaming about. Before the end of the month, they learned the life they thought they were heading into would not be the one they planned after

all. It was then they were told that what the doctors originally thought was a bothersome throat due to allergies was much more than that.

An aggressive tumor was growing in Don's throat. At that moment, not only did their dreams for the future shatter but also what they knew of their lives from day to day.

They traveled to Johns Hopkins in Baltimore, Maryland, and saw one of the top ENTs in the nation, who sent them back home with the assurance the doctor they did have in their new hometown was the best surgical ENT second only to him. With a little more confidence in their course of action, the two returned with more hope but heavier hearts.

Seven months later Don succumbed to throat cancer that had moved to his bones and lungs. Gerry was devastated. Like most of us faced with an unexpected death, Gerry wrestled with the same questions, "Why now, God?"

Gerry remembered what she understood as the plan for her life. It was then, as just a little girl, she knew that one day she would have a ministry. When she was young, she could see the projection of the life of who she would one day become.

What she couldn't know was who she would marry. What the age difference in them would be. Or what DNA his parents, grandparents, or great grandparents would pass down to him that would make him susceptible to this kind of fast-growing tumor. Becoming a widow before she was even old enough to retire was never part of her planning.

And yet, as she placed her hope in the Lord, she was walking the path God prepared her to walk down. It wasn't until her life shattered with the death of her husband that she could understand that the plans for her own life were not to be traveling while living the high life. He had a bigger plan for her.

Would God have been good with the couple enjoying their retirement years, traveling and healthy? Of course. But when sickness and death came to their doorstep, the plans they had made no longer seemed important. The best parts of their lives began to rise to the surface. Instead of seeing the world, God brought people to their doorstep who mattered the most to them.

While we think we are writing our plans in permanent marker, God is marking wide strokes across the landscape painting with watercolor hews we can only see through the lens of retrospect.

It's often said, "Man makes plans, and God just laughs." Well I have a different take on that. I believe a more accurate version: "Man makes plans, and God laughs and says, 'Come on! We can do better than that! Let Me have a turn.'"

## Adjust Your Eyes to the Light

Living in the early twenty-first century America, we can only imagine the hardship previous generations had to face. And yet we face a different kind of threat to our ability to live the life God planned for us. We run the risk of our eyes adjusting to the darkness.

After a long conversation with my daughter, who was struggling through a hard time early in her marriage, I asked her to write down what she dreamed her life would be. To allow her mind to see deep in her heart and write what she wanted her life to look like. Then I instructed her to as honestly as possible write what her life actually was. The gap, I explained, will show you the steps you need to take to get from where you are to where you want to be.

Several weeks later I asked her if she had done the exercise I gave her. She looked down and confessed she had not. With sadness dripping off her voice she revealed it was too painful to see how far apart the reality of her life and her vision had become. She was afraid to

write it on paper. It was too hard. She wasn't ready. Her eyes had adjusted to the darkness; she felt safer navigating the obstacles.

If this is where you are there is something you should know. You are not alone. And the God that created you can still be trusted. His plans are still within your grasp.

> The LORD is my shepherd, I lack nothing. He makes me lie down in green pastures, he leads me beside quiet waters, he refreshes my soul. He guides me along the right paths for his name's sake.
>
> —Psalm 23:1–3

You don't have to feel your way along dark corridors. Nor do you have to fear the light of truth. This is where you must learn to trust.

> Trust in the LORD with all your heart and lean not on your own understanding; in all your ways submit to him, and he will make your paths straight.
>
> —Proverbs 3:5–6

To plan our lives based on our wants and desires often takes us on roads fraught with regret. There are too many variables that we are not in control of to guarantee happiness. When we make plans, we have our sights set on our success. Right? That only seems logical. Who plans for a failed marriage, abuse, sickness, or death? Our happiness, we assume, is based on our successes. We plan according to what we believe will make us successful and happy—then life throws it to the ground.

When was the last time a day went totally according to your plan? We can't plan our day, let alone our lives. We can sketch it. Sketching is putting pencil to paper and lightly drawing the shapes and defining what you see in your mind's eye. It's never done in permanent marker

or with bold lines. The lines are made with room to change and grow as the vision of what it is to become progresses. The final masterpiece is yet to be revealed. Life sketching leaves room for the Master Artist to fill in and create the beauty we don't have the ability to see. Allow God the Father to come behind you, wrap His arms around you, and cup your hand in His. Life sketching is allowing His hand to guide yours over the canvas of your life.

## Fragments of Reflection

Do you allow yourself to daydream, some quiet time to gaze out the window? Do you allow yourself to be quiet before the Lord and listen for His voice? Sometimes we get so bogged down with the cares of our daily lives, just getting through the day, we don't take time to listen for His voice.

Everyone has a purpose, and there is meaning for every life. We just have to listen closely to the voice of truth.

> For I know the plans I have for you . . . plans to give you hope and a future. Then you will call on me and come and pray to me, and I will listen to you. You will seek me and find me when you seek me with all your heart. I will be found by you.
>
> —Jeremiah 29:11–14

## Be Still

In the stillness, as the name of the Lord slips through your lips, seek Him with your whole heart. He is listening for your voice. The plans He has made can be found. He can be found.

*Lord, hear my cry. I want to know You. I want to find You. I know You can hear my voice through my cries. But Lord, sometimes it's hard to hear*

*Your voice over my own. Show me the plans You have for me. Lead me to the life You have for me. Give me a new vision. Not one of my own making but rather one that pleases You. Show me the pieces of my life that need mending. Show me a new vision; etch its picture on my heart.*

## Life's Puzzle

Remember that puzzle we threw up in the air in chapter 3? What are the corner pieces to the picture of your life? These are the pieces that hold the frame, the foundation, and the borders of your world in place. Just as every life is unique, each person's corner pieces will be slightly different. But we all share some basic needs: relationships, faith, careers, passions, family. Within each one of these contains scores of subcategories that fan out into the center of our lives. What does that picture look like now? Today. And then ask yourself, what do I want it to look like? As hard as those questions are to ask, the most important question is, *Father, what did You have in mind for me when You created me? What were Your plans for my life?*

Look closer at what Jeremiah 29:11 says, "For I know the plans I have for you." Notice he doesn't declare, "I know your plans." Nor did he say, "I know your fate." No. He says *He* has plans for you. It's also important to point out the plans He listed don't include teaching you life lessons by taking away people you love, tempting you with addictions or affairs, or subjecting you to abuse. These were not part of his plans for you. It's quite the opposite. His plans are to do you good, to prosper you. There is a plan in the divine mind for your life.

A plan is a design for the future. It is filled with hopes and dreams of the best. When we make plans for our children, we dream of them living the best life possible. A plan is a projection of

hope for something good we want to happen. God has a projection of hope for the good He wants in your life.

Although we often miss the mark doesn't mean He hasn't taken into account the mistakes we have made and factored them into His plans. Think spiritual GPS navigational system. He doesn't panic or get mad when you miss a turn. He will always bring you back to His divine plan. However, the GPS in your car doesn't activate itself.

Here is the key point.

He knows. But you must ask Him. If He were to just roll out His plan without your permission or without you asking Him what it is, then it wouldn't be a plan—it would be a program. To be programmed would mean you have no choice. Your life and your actions would be hardwired in. Instead you are encoded with His plans, His hope of what you would bring to this world. You have the ability to fulfill the plans He has for you—because that's how you are designed.

Those corner pieces, are they what you know they should be? What they could be? What do you long for them to be? What does your marriage look like now? Or what does being single look like now? What about your relationships? Career? Health? Faith? Can you identify the four corners that hold your life in place?

Are you afraid to look at some of the pieces because they look so different from what you dreamed they would? Or perhaps one of the corners is missing entirely or is badly damaged. That is how I felt. For my entire adult life up until that point, I had a vision of my home and the children that filled it. A place where my children would grow up and bring their children back to relive their child-hood memories and create new ones. I wanted my home to be a place where memories of laughter in the sandbox, building tree

houses, and playing tag among the butterflies in my garden would carry them into adulthood. I dreamed that one day we would pass it on to another generation. That we would live close by and watch another batch of children grow. Then I watched death chew that corner piece until it was unrecognizable.

Now is the time to ask God about the plans He has made for you. What were His dreams for your life? I once heard the story of a little boy whose mother asked him, "What are your dreams?" He replied, "Pssshh, I don't have any dreams." Surprised his mother asked, "What? Why not?" He smiled and said, "I just let God do the dreaming for me. His dreams are so much bigger than mine."

Finding out God's plans for our lives is not as mysterious as we often think it is. Neither is it as hard as we think it is. When we don't seek God's plans, then things happen, we fall back into the "everything happens for a reason" or "it must be God's will" ditch.

Maybe, like my daughter, you know very well what it is you were designed to do with your life. But it's been too painful to see it in black and white. Perhaps you haven't had the strength to turn on the light, and your eyes have adjusted to the darkness so long you've given up.

You can begin sketching your new life. Your mind's eye knows who you are, who you were meant to be. The events in your life do not define you. What you choose to do with them does.

If you are ready to start sketching your life, begin with a journal or a blank piece of paper. Write down the vision you see written on your heart. Then take the brave step of writing out where you are today. The gap between the two is where God can work. There will be some areas you cannot change. Those you will leave up to Him. Then there will be areas you can change.

That's where you will find new strength in the hope of Christ for your new life.

Choose a corner piece. Ask your Father to show you the vision He has written on your heart for that area of your life. Write down how you envisioned your life would look now. Then write what it truly looks like now. Be starkly honest. This is for your eyes only. The gap between the two is where you will see clearly the next steps into this new world you've been thrust into.

Pick up one corner piece at a time.

The process of putting a puzzle back together is not fast. It is deliberate. One piece at a time. There is no time limit. This is your life and your healing. You can trust that your Father has planned the landscape of your life. There are countless seeds He has planted in your life that you had no idea were there. Some you have forgotten completely about. But they have been lying dormant, like the lodgepole tree seeds waiting for the fire to break it free.

## Prayer

Father God, You alone know the plans You have had for my life. I ask You in Jesus' name to reveal to me what piece you would have me to pick up.

# Chapter 8

# The Law of Fierce Opposites

The greater the love the greater the grief, and the stronger the faith the more savagely will Satan storm its fortress.

—Douglas H. Gresham, in the introduction to
*A Grief Observed* by C. S. Lewis

wanted that baby. I prayed for . . . no, I demanded that baby. I thought God was supposed to give me the desires of my heart. And my heart's desire was to have a second child before we left Germany. Folded over in pain, I could hear the blood slapping the toilet water with each contraction. With tears running down my cheeks, I tried to muffle my sobs. My toddler was asleep. My husband was gone. The chill of night fell heavier so far from home. Just shy of my twentieth birthday, I was miscarrying alone.

Mike was stationed in Berlin as an infantryman. His work shifts rotated in what they called blocks. For eight weeks he was home and went off to work in the morning and came home in the evenings—a typical workday schedule. Then there were the eight weeks he had to live in the barracks on base. I was allowed to come and visit him, but he had to stay there in the barracks without us. That night he

was in the block that took him far away in another country deep in the mountains for training. He couldn't be reached. He couldn't come home. To get word to him that there was an emergency would take hours if not days for him to receive. Then it would be days if not weeks for him to get home. There was no one to call.

Crawling up on my bed with the light still on, at two in the morning, I curled up in a ball of tears. I closed my eyes and envisioned myself climbing up on God the Father's lap like a little child. Burying my head in His chest I cried. I told Him how bad I hurt. The physical pain of the miscarriage paled in comparison to the grief tearing at my heart. I was frightened, alone, and felt like a lost little girl.

The words to the song, "Give Them All to Jesus," began to run through my mind. Give them all, give them all to Jesus. Shattered dreams, wounded hearts. The song promised He would turn my sorrow into joy. At that moment I didn't know God could turn my sorrow into joy or could wipe the tears from my face. I used some of the phrases as best I could remember as a prayer. All I knew was that I hurt, and I needed God the Father. It was then I felt, for the first time, joy swell up inside of me and physically swallow my sorrow.

For a moment my mind actually tried to stop it. It didn't make sense. This is wrong. You just *lost a baby*. You are supposed to hurt. You are not supposed to feel happy right now. Looking back, I think I tried to push the feeling away—and tried to feel the pain again. Instead of feeling the pain of losing my baby a peace washed over me I didn't understand. It allowed me to fall into a deep sleep. Morning came in an instant. I was still in the same fetal position, and the bright ceiling light faded into the morning sun.

## The Law of Fierce Opposites

Although I had no idea what I experienced that night, other than a miscarriage, it was my first encounter with the power of the

law of fierce opposites. The law of fierce opposites is the powerful spiritual twin of Isaac Newton's third law, "For every action, there is an equal and opposite reaction." Just as a third unseen force is created between the two opposite ends of powerful magnets when pushed together, so too is the incomprehensible peace of the Holy Spirit. His love, grace, and provision are the equal and opposite reaction to the tragedy in the lives of all who love him and will call on His name.

It is an unseen constant presence. Just as the unseen constant of Newton's third law. Science is the discovery of God's handiwork. This is a natural law put in place by the Creator. We live with this law of nature daily without really giving it much thought at all, and yet it is a powerful part of our universe.

Defining this spiritual force is like trying to explain wind. You can only see wind as it makes a tree bow low to it. You feel it as it gently strokes your face as a breeze on a hot summer day. You fear it as it whips fire into a furious frenzy. It howls without a voice. It turns warm air into icy needles that can turn a person's skin deathly black within minutes. It pushed the sails of explorers into new worlds. And yet we live with it every day and hardly take notice of it. It is simply the wind. It is a force of nature that we walk with daily, and we hardly give it a thought.

With the morning after my miscarriage came a new understanding of the God I was just getting to know. The Father, whose lap I crawled up on in the depth of my pain was not Father Christmas to whom I could present my list. I realized that morning that just because my Father in heaven is the King of kings, I don't have the right to demand my wants. I had prayed for that baby like a spoiled child. Stomping my spiritual foot claiming status as a daughter of the King. Believing that because He loves me He would grant me the desires of my heart. The truth was, my desire was to have another child *paid for by the military*.

We only had a few months left before my husband was to be released from the service. I had plans. We had a timeframe. I believed that if I asked God to give me this second child and believed with all my heart that He would give me what I asked, then my plans would all fall into place. I was approaching the God of the universe like He was a cosmic genie. If I pray these words over my plans and sprinkled in a little faith—my wishes will all come true. That's not how it works.

God is not a genie. He is the creator, the power and energy that moves the oceans and hung the stars. What it means to be His child is that He can be trusted with my life and my heart. Just as a child trusts her father will provide for her. Trusting God with your life does not mean that everything will work perfectly. It doesn't mean all our plans will succeed. Babies still die. Sin is still rampant. There is still pain, and I am not exempt.

We want to take the reins of our life. We grip what we think we want with a tight fist, and we are dismayed as we gaze at the rope burns across our palms when they are violently yanked away from us. A tight fist of control is self-deception. We cannot control people, the force of nature, or the God of the universe. That does not mean we are powerless.

Scripture explains it this way, "That is why, for Christ's sake, I delight in weaknesses, in insults, in hardships, in persecutions, in difficulties. For when I am weak, then I am strong" (2 Corinthians 12:10). This is the power of the law of fierce opposites.

We are instructed to use this power in our daily lives, in our actions, and in our thought life. Jesus said, "But I tell you, do not resist an evil person. If anyone slaps you on the right cheek, turn to them the other cheek also. And if anyone wants to sue you and take your shirt, hand over your coat as well" (Matthew 5:39–40).

If you are being slapped, there is some serious hate being leveled at you. The equal and opposite reaction to the aggression of a slapped cheek is the submissive offer of the other. If someone takes from you

something precious by force, the equal and opposite reaction is to willingly give them something of more value. You get the idea.

Jesus took it further than our actions alone. He is after our heart as well, "But I tell you, love your enemies and pray for those who persecute you, that you may be children of your Father in heaven" (vv. 44–45). The equal and opposite reaction to someone who sees you as an enemy is to love them and pray for them. This is what distinguishes us from the rest of the world. Jesus brought to us the law of fierce opposites. He spoke of it when he was preparing His apostles for His death. He told them that they would weep and mourn while the world rejoiced. Then He promised their grief would be turned to joy.

Grief can be turned to joy. The equal and opposite reaction to grief is joy. That is what I experienced that night. When I lost Dan, I can't say I had the exact same experience. It would be quite some time before joy entered my life again. What I did have was the equal and opposite reaction known as a peace that passes all understanding (Philippians 4:7). It was a peace that was beyond my mind's comprehension. It was like nothing I had ever known. The pain was still there, but there was also an equal and opposite compress of peace.

## Fragments of Reflection

Giving birth is one of the most painful natural physical experiences life has to offer. Caught in the throes of contractions there is no turning back. It's just hours of anguish and hard work that requires every single drop of energy within your body. Then in an instant, the pain is over. One look at that tiny human in your arms, as scrunched up as he or she is, and your heart is overfilled with joy.

Is there something pressing your life that is so hard it hurts? Maybe it's grief, and you haven't felt the peace or joy that could be

following it. Maybe it's the loss of a career that you dedicated your life to. The power of the law of fierce opposites is still in force.

Imagine two immense energies. Two equal and opposite forces. Between the two is the third force; it is the compress against the pain.

## Be Still

As you take in a breath remember to lift your head toward heaven. When you release it bow your head to the one who knows you better than you know yourself. Trust in the knowledge that He alone knows not only your true heart's desire but also the path in giving it to you. What you face is hard. When placed in the hands of the Father, it will be met with equal and opposite power on your behalf. You can trust that whatever you face, there is a power to match it.

## The Law That Changed the World

When the early church grasped on to the power Jesus brought—to meet hate with love, persecution with forgiveness—it changed the course of history.

Who, living in the twenty-first century, can imagine with the slightest accuracy the horror of the Roman Coliseum? It was a time when Christians were fed to lions to entertain an audience. It wasn't just lions, it was wild beasts of all sorts. Captured beasts of prey tormented by wicked men and then turned loose to shred and devour the flesh of humans. The animal, of course, is acting on its survival instincts. Man, on the other hand, was acting out of the darkest side of humanity. The seeds of cruelty, hatred, and the murderous, sinful nature that lurks within us all were given the perfect environment to thrive. Every depraved act was on full display to entertain the masses. Gladiators, although glorified by Hollywood, were mostly criminals forced to fight one another to the death. The early Christians, along

with petty thieves, died the most gruesome and painful deaths the Roman mind could conceive. And yet how they met their fate changed the world. How? By demonstrating the power of the law of fierce opposites. This law will change your life as well.

In AD 64, during the reign of Nero, Christians, who would not bow down to other gods or to the emperor, were hated and forced underground to meet and worship. They were considered evil, used as scapegoats, and charged with cannibalism (misunderstandings of communion and due to their meeting in secrecy). They were even blamed for a fire that destroyed half of Rome. The early church felt the full wrath of the Roman Empire.

Tacitus was a senator and historian who witnessed the plight of the early Christians within the Roman Empire. As recorded in *The People's Bible History*, he writes:

**For this purpose he punished with exquisite torture a race of men detested for their evil practices, by vulgar appellation commonly called Christians. Nero proceeded with his usual artifice. He found a set of profligate and abandoned wretches, who were induced to confess themselves guilty, and on evidence of such men a number of Christians were convicted, not, indeed, on clear evidence of their having set the city on fire, but rather on account of their alleged hatred of the whole human race. They were put to death with exquisite cruelty, and to their sufferings Nero added mockery and derision. Some were covered with the skins of wild beasts and left to be devoured by dogs; others were nailed to the cross; numbers were burnt alive; and many, covered over with inflammable matter, were lighted up, when the day declined, to serve as torches during the night.**

In the classic novel *Quo Vadis*, Henryk Sienkiewicz vividly describes what must have been their plight, "All pity died. It seemed as if people forgot how to speak and remembered only the one, endless exclamation: 'Christians to the lions!' The exorbitant cruelty was met by an equally determined martyrdom. The Christians were going to die willingly."

Many converts died with their eyes toward heaven and with hymns and prayers on their lips. They refused to fight, just as Christ was led like sheep to the slaughter, so too were the early Christians.

Throughout Christian history stories of people, real people not unlike you and me, have faced injustice and horrific deaths, tragedy, and trauma. However time and again we see something beyond our ability to comprehend emerge. People who have gone to their deaths with a peace that is so powerful it radiates from their faces. The powerful image of peace and forgiveness in the stark contrast of the vile hate that is engulfing their very lives. The concept alone is hard for our minds to grasp. It is a power few understand or have experienced. It is the power of the Comforter—the Holy Spirit emerging creating the fierce opposite.

The Son of God revealed to the world what this looked like in human anguish when He was accused and sentenced to death. As His body hung on that Roman torture device, a cross, He prayed for the forgiveness of His captors. His death so shook the world that to this day it divides history between before and after it. His early followers shook the hearts of men, not in their preaching but in their suffering. It was not simply what was done to them but their fiercely opposite reaction. How they *chose* to react. Praying for the forgiveness of the man that is about to burn you as a torch in the night brought a kind of light the world had never seen before.

The world around us is filled with stark contrasts that seem to be disconnected. Polar opposites. To meet cruelty with kindness and betrayal with forgiveness does not come to us easily or naturally. And yet if you look around you will see the contrast throughout creation—in both the physical and spiritual worlds.

When it is witnessed firsthand, it is life changing.

Life is filled with pain. Sorrow is always present. We know all too well that life can change in an instant. Sometimes life shatters with change. Other times it's natural, like winter breaking into spring. The darkest of night giving way to the dawn. These opposites are beautiful contrasts. In the same way, there are opposites in the spiritual realm both beautiful and frightening. They are as fierce, majestic, and stunning as a roaring lion. Beauty, grace, and deadly power illustrated in flesh and bones, which is also in the spirit.

The Bible describes the truest love as selfless. Romans 5:8 says, "But God demonstrates his own love for us in this: While we were still sinners, Christ died for us." Love, the essence of life, is sacrificial death. When you think about it, they seem like two opposites—life and death. They are tied together. They are two sides of the same force.

There is a far more powerful force than control—trust. Trust that your Father in heaven is far more powerful than a cosmic genie who will do your bidding. Trust that there is far more to life than you can see in front of you. But most importantly, trust that His love for you will lift you above the depths with equal and opposite power.

After my cold, painful night in Berlin, I saw a sunrise that brought with it a new understanding of the depth of God the Father's love for me. I didn't understand the power of fierce opposites that night. It didn't matter. His laws govern the universe whether we know or understand them or not.

## Prayer

*F*ather God, You hold the power of the universe in Your hands. You created the laws of nature and of the spirit. Although I try, I often fall short of my own expectations. Pain and suffering are all around me. I can't keep the people I love forever, I know that for the very amount I love them, I will grieve for their loss. But You, Lord, have given me a peace beyond all comprehension. In You, Father, I trust. I relinquish my need to control my life. And I open my heart and hands to the hope and peace You have for me.

# Chapter 9

# Harnessing the Storm

Freedom is the individual's capacity to know that he is the determined one, to pause between stimulus and response and thus to throw his weight, however slight it may be, on the side of one particular response among several possible ones.

—Rollo May

The funeral director told us to be careful with his face. Dan took the brunt of the impact of a two-ton truck. We were grateful an open casket was possible. The night of the visitation our family was asked to come in and see him privately. I suppose it's so the initial shock of seeing your child in a casket isn't in front of the entire community. The body lying there looked like my boy, mostly. As much as it was possible without life in him. Danny's big sisters fussed with his hair. They wanted his bangs to sweep gently over the corner of one eye. It was his brand of boyhood. He was flirting with being cool. As he laid to rest in his Civil Air Patrol uniform, his handsome face was hard not to touch. His sister Sarah gently brushed his cheek one more time. His lips ever so slightly parted. As fluid seeped from the

corner of his mouth, Sarah screamed and fell back. Our peaceful acceptance and muffled sobs immediately gave way to gasps of horror. Bellowing cries erupted throughout the room as Sarah collapsed into a chair shaking uncontrollably. Her big brother, Chris, slipped his arm around her, and with a tight squeeze whispered in her ear, "Well he did it. He got the last scare on you, Sarah. I bet he's laughing hysterically watching from heaven." Within that instant, the thought of Danny getting the last laugh by scaring Sarah one last time turned her tears into laughter.

A horribly gruesome sight and a heart-wrenching moment. All the work the mortician did to try and beautify death had failed. Nothing could change the facts. There was our baby boy in a coffin and the wet reality of his death dripping in front of us. What changed in an instant was simply how we chose to see it. I don't believe this terrifying moment really was Danny's way of playing a final joke on his sister. She didn't either. It didn't matter. It instantly erased an unthinkable thought with laughter. Immediately taking us from screams to laughter. It allowed us to once again think of our boy alive and of his love for finding new ways to make his sisters scream and laugh. The situation did not change. The way we responded did.

> Finally, brothers and sisters, whatever is true, whatever is noble, whatever is right, whatever is pure, whatever is lovely, whatever is admirable—if anything is excellent or praiseworthy—think about such things.
>
> —Philippians 4:8

If God came to me before Dan was born and said, "Here's the deal: I will give you this boy to cherish. But you can only have him for thirteen years, and then you will mourn him the rest of your life." Would I take it?

Yes.

When that thought came to me, it was as though I accepted his terms of the deal posthumously.

I would absolutely take the deal. Knowing what I had to gain in having him, he is worth the pain of not having him. And if that is so, then I realized I must be thankful for the time I had with him. If I took that deal, then I had to be grateful for the years I had him. I had to look at what was there—not what was shorted. A choice had to be made. I could choose to continuously think of what was taken from me. Or I could think of what a wonderful gift was entrusted to me for a short time.

Gratitude is the simple but powerful act of being thankful. We say thank you all the time. Being thankful for what you have or to someone for what's been given is part of our culture. It's easy to be thankful when things are good. But that's really just the polite thing to do, right? Someone who shows no gratitude for the kindness that has been given him is considered rude, not to mention self-centered. So we practice on a daily basis our manners in being thankful for kindness. But what about when there is no kindness to be found? What about when it is the worst possible time imaginable when there is nothing to be thankful for?

Well-meaning people often try to thrust gratitude on others. Gratitude cannot be transferred from one person to another. Simply put, you cannot tell someone to be grateful. Neither can you expect someone to be grateful when they are not. Gratitude is something that must come from within. One of the worst things a person can do when trying to help someone who is hurting is to attempt to give them something to be grateful for. When it is thrust at you with a "look on the bright side" attitude, it denies the true impact of the hurt you feel.

To be grateful in a situation does not mean you cannot grieve. It does not diminish the pain of loss. What it does do is strengthen your soul and give you peace in the storm. Gratitude has an

amazing power to heal. It can transform any situation. How many times have you had something happen and then once the panic and fear were gone, you see that it could have been much worse? You are thankful for what did not happen.

Oftentimes something happens, and we consider it horrible. We fight against it. Then after it is all over, there is a benefit, and we call the whole episode a blessing in disguise. We are only able to be grateful after it is all over. I call that rearview mirror gratitude. We can only appreciate it once we see the benefits it gave us. If you practice rearview mirror gratitude on a regular basis, it builds your faith. Going over a situation and looking for what is good or praiseworthy is part of the process of renewing your mind.

Gratitude is not just positive thinking. It is an exercise of your spirit making your reasoning mind bow in obedience. No one can give you something to be thankful for. It is a decision you must make. Because only you can find the things that you can be thankful for.

There is an old saying, "I used to complain about not having any shoes until I met a man with no feet." Oftentimes we look at someone else's plight, and we can be thankful it's not us. That form of thankfulness may feel wrong, yet it's a common reaction. I was thankful I only lost one son. There are many people who have lost more than one. I can be thankful I did not lose two in one accident. As strange as it sounds, I was also grateful it was my family that suffered the loss and not the family riding along with my boys. That does not mean I was thankful it was my son who died. I was thankful a family I loved did not have to suffer the death of a son.

Several years before there was a terrible accident in a nearby city. A family was riding in their minivan with their six youngest children. They had three older children not with them. Their vehicle ran over a piece of metal, which snagged and drug down the road until their van ignited. The parents pulled to the side of the road and jumped out of the vehicle. They tried desperately to pull their

children from their seat belts and car seats. With all their might they tried to save their children, but all they could do was pound on the windows trying to break the glass to get to them. Instead of rescuing their children, they watched them die. Their hands were badly scorched by the heat of the glass. The pain of being so close and not be able to get to their children swallowed the pain on their burnt hands.

I didn't watch my son die. When the thought of him being thrown from the truck and dying in a cornfield stabs my heart, I remember this family. Their sorrow did not make me feel better. In fact it made me hurt for them instead of only myself for just a moment. By diverting your thoughts from your circumstances to someone else's tragedy, you change your thought pattern. As you consider someone else's plight, empathy enters your mind and heart. When you take it a step further, you can pray. The next natural response is gratitude.

When I could hurt for someone else, it made the way clear for me to look at my sorrow from a different angle. I could change the narrative in my mind. Once I was able to have a spark of gratitude, I could take control of my thoughts and bring them into submission. Instead of the image of my son laying in a cornfield, I thought of him laughing and telling stories in the back seat of his brother's truck one minute and in the next instant sitting at the feet of Jesus. There was no pain. He died on impact. I chose to be thankful my son died on impact. Just reading those words as they are written seems unconscionable. And yet, in a situation I cannot change, this was something I could be thankful for.

As a family, we would say things like, "Yeah, one-minute Dan was telling his buddies about his football days, and the next minute he had some poor angel trapped telling it about his MVP trophy." We would speak to each other making up stories of what our teenaged boy unleashed in heaven would be like.

When you allow yourself to be thankful within the situation, you take away the power it has on you. While being thankful he died on impact did not change the circumstances, it did take away the power the circumstances had to drag me into the depth of despair.

We can't always see something to be thankful for. It's acceptable to compare our pain with others. To feel, or try to feel how bad it could be, to evoke empathy rather than pain, gives you just a little bit of space for thankfulness. When we make space for gratitude we make room for the Holy Spirit to work in our lives to heal and bring comfort.

## Rearview Mirror: Gratitude on Wheels

Bob's father emigrated to the black dirt of Illinois from Germany when he was just a teen. A few years later Bob's father lost his forearm in a buzz saw accident. Bob often reminisced that he was literally his father's right-hand man from the time he could walk. Growing up on the farm, raising horses, crops, and cattle, Bob became a hardheaded farmer set in his ways—a tall man and a farming version of a workaholic. He demanded a lot from himself and his family. When we first moved to the old farmhouse, Bob was a member of our small community church. He could have played Santa in any parade. But it wasn't the snow-white hair and beard; it was the twinkle in his eyes. That kind of mischievous gleam that comes from growing up in the country and entertaining himself with pranks on family and cows alike.

It was one of the first conversations the two of them had, Bob and my daughter Jami. She was about ten years old at the time. "Do you like horses?" Bob asked, most likely knowing the answer. What ten-year-old girl doesn't like horses? Jami confessed she had always dreamed of owning her own horse. Bob just smiled and nodded and said, "Well, we'll have to see what we can do about that."

By the end of the week, a truck pulled up in the drive pulling a horse trailer. Inside were two ponies, Molly and her best friend and daughter Dolly. "Here you go, Jami." He said, adding one condition, "The rule is you have to feed the horses before you feed yourself every morning. If you are willing to do that, I'll leave them here for you to ride all you want. They are yours as long as you will care for them." He came each night to check in on the lot of them—Jami, Molly, and Dolly.

The winter showed up in the middle of fall in 1995. It was cold, wet, and the wind had a tail that stung like an icy needle. The long days of harvest stretched into the late-night hours. Not a minute of dry weather could be wasted, otherwise crops would be lost. Tractors are known for being more unpredictable than mules ever were. The tough German work ethic and stubbornness had been an asset on Bob's family farm for generations—right up until Bob decided he needed to fix the skylight on the cattle barn roof.

Bob's wife Deanna was out by the barn when she heard a loud noise. As she was calling to him, their grandson walked into the barn. He saw a foot lying motionless underneath the tractor. In an instant, Bob's life was forever changed.

Paralyzed from the waist down, life as a farmer came to an abrupt halt. Bob was no longer a farmer, a cattleman, a 4-H leader, or a horse trainer. He was a paraplegic. Everything he knew as a man was gone. Except for two things: his faith and his family.

Bob spent several long months in the hospital. First healing from his injuries, then moving to rehab to learn how to function without the use of his legs. His only son took over the family farm, and Bob was left to the task of examining what was left of his life.

After about two years in a wheelchair, I asked Bob a question you might think odd. But as I had watched him struggle over the years, I thought I knew the answer.

"If you had the chance to have your legs back, but you would go back to the man you were before the accident, would you take it?"

Without hesitation, the answer was just as I suspected it would be. A resounding no.

It was in a hospital bed that Bob reached out in tears to Jesus. Bob begged Jesus to heal him. But healing never came. At least not to his legs. Healing came in every other area of his life. His wife and high school sweetheart became the light of his life once again. As his adult children came to his bedside, everything else was stripped away except their love for him. Bob's life was transformed from one as a busy, demanding farmer into a man who understood the value of his relationship with his God, wife, and children. Where there was pain, loss, and helplessness God raised up the man. God was much more concerned with the man he knew Bob could be than his legs. Bob had become much stronger, kinder, and a more loving husband, father, and grandfather. He stood taller in the eyes of his family in a wheelchair than he did on legs.

## Brave Suffering

> Instead of possibilities, I have realities in my past, not only the reality of work done and of love loved but of sufferings bravely suffered. These sufferings are even the things of which I am most proud, though these are things which cannot inspire envy.
>
> —Viktor E. Frankl

Facing the suffering put before us does not invoke envy. No one envies a man or woman who suffered in a concentration camp. No one envies a widow, a cancer patient, or a paraplegic. And yet how is it that Viktor Frankl can say pressing into his suffering is what he

is most proud of? How could Bob say he would not trade his legs for the life he has as a paraplegic? Looking on the outside, both of these men lost everything they loved.

Frankl explains it was not that he left the death camp alive or that he had the strength to survive. It was that he left it with his humanity. He made a choice to suffer but not cause suffering. To be afflicted without causing affliction. He helped his fellow prisoners. He clung to the memories of his wife and the hope he would see her again. He pursued his work as a psychiatrist not for fortune or prestige but rather for his own soul. In doing so, he lived the life God created for him even while in the face of unimaginable suffering and evil.

How often do we do things for our souls? What are you most proud of? Is it your accomplishments? Would you say it is your family, home, or education? Those can all be lost.

How we endure injustice is something that cannot be taken from us. Your rights can be stripped from you. So can your home, your loved ones, and even your dignity. But what can never be taken from you is your ability to choose what you will do with the situation.

I've often heard people make conjectures of what they would do in certain situations. Whether or not they would want to live under certain circumstances. The idea of being bedridden or a paraplegic sounds to some a fate worse than death itself. But there is one thing these people are not thinking of—the power of the human spirit. The very breath of God fuels our spirit.

The will to live—to see the face of someone you love again or to finish the work you believe you have been put on this earth to do—is an extremely powerful force. It is equally as strong as the force opposing it.

Man has long understood that he has the ability to harness power. The powerful and majestic horse can be bridled to serve man. The same fire that can destroy everything in its path can warm a family and keep them alive. Gratitude is a powerful enough force to harness any circumstance and take away its power to hurt you.

## Not One Wasted

"My body is revolting," Josie Siler explained. She has experienced a lifetime of chronic illness. Josie doesn't consider the names of the illnesses important. The years of poking, prodding, tests, and medications really fall under one name she calls "productive misery." Josie says she has been able to look back at each crisis, each challenge, each uncomfortable treatment, and see God's hand in it. Her rearview mirror gratitude has given way to a faith that has allowed her to face each new treatment and crisis as an opportunity for God to take her body to the next level of healing— and pull her closer.

"I would never choose to go through all of this again," Josie confessed, "but I am thankful for it because it has brought me closer to the Lord. I have learned that it's not my life I live, but I live united with Christ. He lives through me. I have learned who He is and who I am in Him. I have learned that my spirit, who I really am, has died with Christ, risen with Him, and is seated with Him at the right hand of God. My spirit is who I really am. My spirit is already healthy. That's the position I choose to live from. I choose to find my identity in Christ. Without the trial of illness, I'm not sure I would have learned how to do that. I am so thankful for each trial that has led me closer to the Lord. Not one of them has been wasted."

Not one wasted. Josie has learned to harness the storm. When she told me she didn't believe she would have the depth of relationship with the Lord that she has now without going through these trials, it was easy to see where she found her gratitude.

> Rejoice always, pray continually, give thanks in all circumstances; for this is God's will for you in Christ Jesus. Do not quench the Spirit. . . . Hold on to what is good.
>
> —1 Thessalonians 5:16–21

Between the diagnosis and response, there was a space. In that pause, Josie purposefully chooses her response. In her response, she has found growth and freedom.

## Fragments of Reflection

What do you have to be thankful for in your situation? Maybe you can't think of a thing. If so, can you think of something to be grateful for in this very moment? Take a moment to look in your rearview mirror. Is your situation as bad as it could be?

If you cannot think of one thing to be thankful for, you can be grateful for the air in your lungs. Is there a song that ministers to your soul? Why not sing it?

Gratitude is part of renewing your mind. You can't stop the storm, but you can be thankful for the rain and trust God will use it to cause you to blossom. We often think of gratitude as a duty, something we should do if we want to be a good person. In reality, gratitude is a gift. God teaches us to give thanks so we can make a clear path for Him to work in our lives.

## Be Still

*Thank You, Father God, for the life You have given me. I can't see what You are doing behind the scenes on my behalf, but I trust that You are moving. Thank You for loving me. Thank You for being a God who is ever present. When I can't see past the moment, You see my entire life. You alone know the number of my days. Show me, Father, how to walk through this and come out a better person. Someone I can be proud to be, but not for anything that can bring envy.*

## The Power of Words

> Pay attention to what I say; turn your ear to my words.
> Do not let them out of your sight, keep them within your
> heart; for they are life to those who find them and health
> to one's whole body.
>
> —Proverbs 4:20–22

In the beginning God spoke into existence the earth and stars. Words have the ability to put the power of life directly into a fellow human being—and the power to destroy them. Sometimes the most powerful forces around us are ones we pay the least attention to.

We have harnessed the power of electricity—the same power that can light up the night, start a fire, and kill a man in an instant. And yet we live with it every day. We flip switches with hardly a thought. It is tamed.

There's a lot of attention drawn to bullying. Few of us get through childhood without encountering a bully. Then, of course, bullies grow up and become adult bullies. They're easily found in every profession. With the advent of social media, the art of bullying has risen to a new level. It has driven children to suicide and even murder.

What is the power behind it? As a child of the sixties, I was taught to combat bullies with a poem. "Sticks and stones can break my bones, but words can never hurt me." Add a little childish twang of defiance to it, and sling it at the forehead of your nemesis. Seems a little oversimplistic doesn't it?

Maybe it was, maybe not.

Truth is, that little ditty was a shield. In order for it to work, you had to not accept the words that were thrown your way. They are fiery darts.

The furniture company IKEA did an experiment on the effects of bullying. They used two identical plants, each encased in its own environment. Each had the right amounts of water, light, and soil to thrive. They were placed behind a glass wall for observation. There was one seemingly minor difference between the two plants' environments. Each environment had a speaker that broadcast a human voice. One spoke kind words of praise and encouragement. The other had the opposite—negative, hurtful words, the kinds of words that would be used by a bully.

They got students involved. The students recorded both bullying and encouraging words to be added to the recordings being broadcast over the plants. The bullies used the usual— you're ugly, nobody likes you, you're stupid—you know the shtick. It hasn't changed over the years. And the opposite was said of the other plant. Can you guess what happened? The bullied plant, in spite of its ideal physical environment, no longer thrived. It wilted, drooped, and began to grow at a much slower rate than the plant that enjoyed the kindness of the speaker and all those who came to visit.

IKEA wanted the students to see the effect of their words—even on plants. Their hope was that students would become aware of the devastation bullying does and understand it has a hurtful impact on people too. A noble gesture indeed. However the problem is not that teens don't know their words can hurt another human. Well they were probably surprised words can hurt plants. Nonetheless they are well aware of hurtful words.

We have all been hurt by someone's words. You don't have to be bullied to be devastated by what someone says to you. In fact some of the most hurtful words were never intended to hurt. Some of those words come from our own parents. Oftentimes they are intended to have the opposite effect. How many times have you said something negative in hopes that it would make that other

person think—and react—positively? But did they? Why? Because words are powerful when we neglect to put up our shield and let them in. Or we accept them as truth.

Do you believe the plants thrived or faltered because of hurt feelings? I'm not convinced it was an honest experiment. Yes, one plant thrived and the other was hurt by the words spoken at it. But there is more at play here than hurt feelings. There is more behind the power of our words in the universe that impacts creation than mere hurt feelings.

Do rocks cry? Do plants feel? Is there the power of life and death in the tongue?

Yes.

It is true. The same God who made radio waves and microwaves made negative and positive energy waves.

> This day I call the heavens and the earth as witnesses against you that I have set before you life and death, blessings and curses. Now choose life, so that you and your children may live.
>
> —Deuteronomy 30:19

Thoughts once accepted become words. There is power in your words.

If you tell yourself there is no point in living, then you will find no point in living. If you tell yourself that life is good, in spite of the sorrow, life will become good in spite of the sorrow. When you use your words as blessings, you will have the blessings.

To choose gratitude in the midst of the storm is to speak life into your own spirit and all those around you. Between circumstances and your response, there is a space. God has given you the power to choose your response. In that response, you will choose growth and freedom or destruction and bondage. Choose life.

# Prayer

*F*ather God, I choose life. I choose blessings. I will hold fast to Your love and Your promises. There is pain all around me, but You are my refuge. Teach me, Lord, how to renew my mind and harness the power of thanksgiving and praise. Show me, Lord, in every circumstance Your fingerprint. Give me eyes to see what You are doing. And where I cannot, give me the peace to know You will turn whatever I face into something I can point to. As I travel down this road, Lord, let me look back and say, "All seemed lost, but God [fill in the blank]. And I am thankful."

# Chapter 10

# Living the Blessed Life: According to Christ

*I*t's always darkest before the dawn. That's what I kept telling myself. Until that morning. "I can't see God in this, Debby." It had been two years since a blood clot almost killed my husband. Two years. No work. No income. The doctor refused to allow him to go back to work as a police officer. With seven children still at home, the situation felt grim. "I can't feel him anymore," I told her, half crying, half complaining. My faith had come to a dark, abrupt halt.

A massive blood clot went to both of Mike's lungs. He survived, but his career in law enforcement didn't. Within days of his being admitted to the hospital, our small church held an emergency meeting on our behalf. One of the elders in the church asked for a listing of all our expenses. From that day on, each week an offering was taken for our family. Each household made a pledge according to their own ability to give. Some gave ten dollars and others gave more. Looking back those small gifts often turned out to be the biggest blessing. Someone would come by and say they weren't at church or they had forgotten their wallet that Sunday. Then they would hand us the right amount of money for what we needed that day. This went on for two years. Every single week an offering was taken for our expenses. There were times when someone would

stop by from grocery shopping for their family and bring a bag for us. I remember one time we were brought a bag of groceries in the morning. In it was a package of hotdogs but no hotdog buns. That evening someone else came by and brought a bag that had buns but no hotdogs. We were blessed by their giving and completely amazed and humbled all at the same time.

With law enforcement no longer an option, Mike decided he would try to go into private investigations. This way he at least would have to confront the bad guys and would have a better chance of avoiding blunt trauma. Which now, with his blood clotting disorder, was a real concern.

He had applied at several companies as an investigator. The blessing of our church family reaching out to us, caring for us, making sure we kept our home and vehicle payments up and our children fed, weighed heavy on my pride. We did not have a large family with the intention of anyone but us caring for them. But there we were. What little I brought in from my writing kept us in milk. We needed a miracle. The day I yelled my fear and unbelief into the phone at my sweet friend, I had come to my end. Mike had received another rejection. I couldn't stand the thought of going another month accepting money from my friends.

After enduring my waning faith outburst, Debby prayed with me, as I knew she would. Then I hung up and cried some more. My God was nowhere to be found. Or so I thought.

The very next day, Mike got a phone call. It was from one of the companies that had rejected him. The owner himself wanted to know why he wasn't hired. When he was told that it was due to his rural location and that he would have to drive two hours one way to work, the owner gave instructions to hire Mike anyway if he'd take the position. He did.

That position started out at a rate of pay that was twice what he made as a police officer. Not only had God showed up, He did it in

a way that blessed us more than we could have ever dreamed. An entire new profession was opened to him as he was closing in on fifty years old.

What I couldn't see was God working behind the scenes, the conversations that were taking place that I had no way of foreseeing. My spirit had become poor in faith.

Those years of having to accept help hurt. I was crushed and humbled that we were not able to provide for our family. That friends, who were also struggling to raise their young families, were reaching into their household income to care for mine. You could say it hurt my pride. It did. I did not want to be on the receiving end. I wanted desperately to be on the giving end. That is so much better, right? To feel good about helping someone. To have an abundance you can give out of. But that's not what Jesus said. When Jesus washed the apostles' feet, Peter protested.

> "No," said Peter, "you shall never wash my feet." Jesus answered, "Unless I wash you, you have no part with me."
>
> —John 13:8

Peter could not understand why the Master would wash his feet. There is a lot that can be taken from Jesus' example. But what I realized was that this was a time for me to accept the provisions from my Father who cared for us through our friends and church family. Today, when I look back at those days, I remember how hard they were. In reality, what was so hard was the fear. It was never because we lost our home or because I had to watch my children go without food. That never happened. The pain I felt was my aching pride. My thoughts of how we were viewed. My fears of poverty. And yet we had everything we needed. The worst of it was we didn't always have everything we wanted when we wanted it. I was like a child standing out in the pouring rain with my eyes shut and my

hand in a closed fist. How was I to receive God's blessing—when I didn't want it?

What does Scripture say is a blessed life? The absence of life's trials? God does delight in giving His children good things. All good things come from the hand of God. However, if God's blessings only come when things are good, how could He be a good God when life is unfair and cruel? Our trials come into perspective with a fresh look at what Christ meant when He said, "Blessed is he who." A closer look at the Beatitudes explains how God is good in all of our circumstances.

The Bible tells us that when Jesus saw the crowds of people who came to hear Him teach, He went to a mountainside and sat down to teach all who would listen.

> He said, "Blessed are the poor in spirit, for theirs is the kingdom of heaven. Blessed are those who mourn, for they will be comforted. Blessed are the meek, for they will inherit the earth. Blessed are those who hunger and thirst for righteousness, for they will be filled. Blessed are the merciful, for they will be shown mercy. Blessed are the pure in heart, for they will see God. Blessed are the peacemakers, for they will be called children of God. Blessed are those who are persecuted because of righteousness, for theirs is the kingdom of heaven."
>
> —Matthew 5:2–10

You get the idea. What Jesus considers a blessed life is not someone who anyone would envy. By today's standards, it would look more like: Blessed are the spiritual warriors, for theirs is the kingdom of heaven. Blessed are those who have never seen death or sickness. Blessed are those who can live without carbs.

Jesus knows we are frail. Our original model was formed from the dust of the earth. But if I'm blessed because I am in mourning, it's because I have been devastated. But my blessing is not in the circumstance; it is in comfort. When Josie said she would not have known Jesus without being sick, according to what Jesus taught, she was right. She is blessed. She received from God what no promotion, new car, new house, or winning lottery can give. She chooses to accept what Jesus has to offer in her time of need.

## Of Amish Men and Motors

Have you ever noticed that when your mind begins to wander, more often than not it doesn't roam into blissful territory? When we are facing difficulties, we tend to drift into the negative much more often than the positive. You might have thought patterns that stem from childhood. You may have even inherited them from your parents. When the car won't start, the furnace breaks down, or a strange letter arrives in the mail—what are your first thoughts? For many of us, it's not *meh, it's an easy fix* or *I bet someone is sending me a lot of money.* Too often our minds naturally go to the worst-case scenario.

I was planning a trip to a homeschool conference where I was invited to speak. Money was always tight raising a large family on one income, and there was never a good time to blow an engine—but blow an engine we did. I couldn't see how we would be able to fix the van let alone get me to a conference three hours away in Chicago.

Just when I'd given up the idea of going, my friend called to ask if I could bring her daughter home to Chicago on my way.

"I don't know how I'm getting there," I said, trying to mask my frustration at the fact she even asked. I explained our situation, completely oversharing while indulging in a bit of self-pity.

"I'm not worried about it. I'm praying for you. God will make a way," she told me in a lighthearted tone.

*Didn't she hear me? Didn't I paint a dark enough picture of how bleak my checkbook actually looked?* Out of sheer courtesy, I agreed to bring her daughter home. *If* I could go. I'll never forget the sound of her voice as she thanked me as though she was convinced it was a sure thing. I hate to admit, I wasn't very appreciative of her optimism at my dilemma.

Do you remember house phones? Way back in the day when people didn't call people, they called houses? At the time, we lived on the edge of Arthur, Illinois, otherwise known as Amish country. Where phones hung in sheds, not houses. The Amish are allowed to have phones, just not in the house or in their pocket. To use one, they go out into the yard and into a shed to make a call. The phone sheds could easily be mistaken for outhouses, but inside they were very nice. They are also allowed to own cars and ride in them; they just can't drive one. Whenever they need to go somewhere that is either too far for a horse and buggy or not horse friendly, they hire a driver.

One such Amish friend operated, among other enterprises, a small homeschool bookstore out of his machine shed. He often called hoping to hire me as a driver.

"Hello there," He would begin. His Amish accent and drawn-out greeting made his identity unmistakable.

"Hey, Vernon." I'd slip in as quickly as I could.

"This is Vernon Lambr—" he'd trip over his own tongue as my response registered before he could finish his name. He'd chuckle and finish his sentence anyway.

"I'm needing to hire a driver for the Chicago conference. I see you are speaking up there."

"Well," I explained, "I'm supposed to, but I have a van in my drive that needs a new motor. I don't have the money to buy one or the ability to pay someone to put one in."

What transpired over the next few days was nothing short of a miracle. An Amish man who had never driven a vehicle in his life bought and installed a motor in my twelve-passenger van. Did I mention he did it in time for us all to go to the conference? Along with my friend's daughter, I drove to the conference hauling a trailer full of homeschooling books and an Amish man with motor grease under his fingernails.

What I didn't realize when my friend spoke of her faith in God's provisions was that she didn't have to know the depth of my problems. She had learned how to trust God with problems big and small. My need for a motor to get to the conference was met. And so was hers—and Vernon's.

The imperfections of a hard life can come alive with blessings in the most unexpected places.

## Fragments of Reflection

It's so easy to look at someone else's life and be envious. How many times do we look at someone's life from the outside and decide they are more blessed than us? Maybe their life looks easy. They were born with money. They were handed a dream job. These are all the things we look at and consider blessed. When we are in need of something and God provides it, we believe that's what being blessed by God is all about. But if that were true, then does that mean God only blesses us with material goods? Make no mistake, God provides. He is a loving father. He comes to you in your uttermost weakness, even when you don't have the spiritual strength to storm the gates of heaven to get your prayers answered. When I was poor in spirit, He met my needs. When I have mourned, He comforted me.

## Be Still

*When I am at my worst, You are at Your best. Come to me, Holy Spirit. Open my eyes to the blessing You have given me.*

## My Wabi-Sabi Garden

Around our old farmhouse where I once dreamed I would raise my children and cuddle my grandchildren on the front porch swing was flowers. Lots of flowers. To passersby, it must have looked like I was a meticulous gardener. From the road you could see flower boxes filled with burgundy flowers and cascading silver vines that hung from every window. Our time in Germany made me fall in love with window boxes, especially those on the second floor. There was just a certain charm about it. So I brought it home with me. All around the house were purple coneflowers, Russian sage, lambs ears, and old roses, just to name a few.

Every time the children would leave something out in the yard that would kill the grass, I planted flowers. Many mornings I would begin my day by taking my coffee outside to see what was blooming. My intention, going in, was never much more than to visit and admire God's handiwork. The soft loamy soil under my bare feet always calms my soul. Nevertheless, more often than not, I would end up on my hands and knees digging in the dirt. I lost more coffee cups that way. Distracted by a plant that was calling me to help get a pesky weed out from under it, I'd leave my cup in place of the weed.

One such morning I poured my coffee and began my stroll. Earlier in the spring I had planted a barrel full of flowers. Tipped on its side, I filled the barrel as though the flowers were spilling out

and into the little garden in the middle of the lawn. I was excited to see how well they were doing. As I stood and admired the colors and scene it created, I noticed something was off. Tucked in among the flowers was a pair of kid's dirty summer shoes. I stared a long time at those raggedy sneakers. It was an appropriate illustration of my life at the time.

I worked hard to create beauty in the midst of a house full of diapers, dolls, and dogs. There were always outside elements that changed every picture I'd paint. My natural reaction was to get annoyed at the forgetful child who lost their shoes. But this time the contrast of the child's shoes and my flowing flowers seemed like a picture. I dubbed my gardening style "artful abandon." It was filled with inexpensive perennials bought at the end of every spring. Inexpensive because they were dying. Once they were tucked into the rich black Illinois soil, they would love me for rescuing them. Then they would show their appreciation by giving me beautiful flowers for my kids to kick their shoes into.

In Japanese culture, my garden would be called *wabi-sabi*. The concept is rooted in the fifteenth century and has integrated and evolved in Japanese life and culture so deeply that there is no accurate English translation. It's finding beauty in dirty red tennis shoes tucked under yellow petunias. It's a tied bunch of wildflowers from an overgrown field in place of a florist's artful bouquet of roses. It's the contrasting dark stormy sky framing the naked silhouette of trees in winter. It's finding beauty in life's imperfections.

We live in a world where every picture has a filter. There is a time to take in the life we have with no staging and no filter. More than that, we have to find beauty in it. When we can, we will see blessings everywhere we look.

When Jesus described who was blessed, He described hurting, imperfect people. We are blessed because we can understand what

He came for. God sees our imperfection, our failings, and loves us as His sons and daughters. His perfect, imperfect creation.

We strive for perfection. We envy those who seem to have it all together. It's too easy to judge ourselves unworthy of God's blessing because we don't live up to our own expectations. But His most precious gifts to us come when we need them the very most. When we fail, lose faith, or mourn.

The perfect life is a false image that lives only in our minds. It has no failings, no death, and no sorrow. It is in all actuality, heaven. Here on earth, a perfect life is a life blessed by imperfections made beautiful.

## Prayer

Father God, thank You for the beauty all around me. Thank You, Father, that not only do You provide for our needs, but You also bless us. You bless us in our imperfections. In our hurts and weaknesses. Help me, Father, to see myself the way You see me. Help me to see others the way You see them. I give You my imperfections, and I ask You to show me their beauty. Lord, I am poor in spirit, and I am meek when I think I should be brave. I hunger for Your righteousness and Your mercy. Create in me a pure heart that I may see You, God.

# Chapter 11

# The Free-Falling Hero

Before I formed you in the womb I knew you, before you
were born I set you apart.

—Jeremiah 1:5

As I write, images of the mother I never knew smile at me from
a digital picture frame on the table. They capture my mind
and squeeze my heart. Then aunts, uncles, and grandparents
appear. Pictures of my younger brother and sisters posing at events
I never attended flash and fade away. The digital imagery continues
to reveal face after face that resemble my own. And yet there are no
memories. Like a lonely child peering through a dusty window at
the people laughing inside, I can only imagine what their life was
like, or what mine might have been.

On a cool Halloween evening in 1959, I was born Theresa-Marie
White under a blanket of secrecy in a Chicago orphanage. Six days
later my identity was changed to Rhonda Robinson the strangers
who would become the only parents I would ever know carried me
home.

The need for a family is embedded within the code of our DNA.
As a child grows, she understands the one holding her is her mother.
Being adopted, I was no different. Except for the story I was told. The

truth that was hidden. And the lies I believed. You see, I was born in what is called the Baby Scoop Era, a time when unwed mothers were viewed as unfit to parent a child if for no other reason than the fact she was unwed. Women, with nothing more than love to give, were often coerced into relinquishing their newborns. Keeping a child out of wedlock, at any age, was not done without public ridicule. Public shaming for mother and child was a merciless reality of the time. Instead of celebrating a pregnancy, no matter how much a child was wanted, there were secrets to keep. Shame to hide. Just because it was lawful to have a child out of wedlock didn't mean society would allow it. During the Baby Scoop Era, girls who were "caught" got sent away. They came back a year later with a story of visiting a sick aunt or attending a new school. In my mother's case, they made it look like she went to live with her older sister when she instead went away to a home for unwed mothers. Women like her were threatened to never to speak of it. They were told to forget it ever happened, disappear, and allow the new family to have a chance.

It was standard practice to seal the birth records of adopted children. My identity was changed and locked away along with the story of my parentage. My birth mother was not allowed to put my father's name on my birth certificate. Nor was she allowed to sign her real name. Growing up I let fear of the unknown, along with the white lies about my mother's name and age, define who I was. Although there was never a time when I did not know I was adopted, there was always an untold story hanging over every area of my life. A story I didn't want to know. A story I was afraid to hear. My heart carried unnamed shadows of people I never knew. There were lifetime-sized blanks within my life story. It was fragmented. And so was I. So I filled in the blanks myself with my own lies, my made-up storylines.

One story I told myself went something like this, "I was a mistake. I wasn't supposed to be here." That was the logical conclusion from

the story I grew up with about my origins coupled with my limited understanding of life and the few pieces of information about the mother who birthed me. From childhood I was told the mother who gave birth to me was a young unwed girl of only fifteen (although she was actually nineteen). Nevertheless the lie I believed painted scenes of backseat dates in my mind. Most likely, I thought, my very existence was regretted for decades. I was a mistake that had been "fixed" with adoption.

Or worse.

Believing she became a mother at such a young age led me to fear that perhaps I was the result of rape or incest. I believed this was my story, and I kept it buried deep in my heart.

Believing a lie can have as much impact on life as though it were the truth. It is often said one's perception is one's reality. However, one's personal reality is not always the truth. Perception is the world as it is displayed in your mind. If this storyline were true, it also meant I had no purpose. No meaning. No right to be on the planet. At least that was the story I told myself for many years.

This belief system fueled rebellion. Without realizing it, the ramifications of the story I believed also caused a deep wound that festered and leaked into adulthood. It was my own made up *why* for a life-altering event I couldn't change and didn't understand— rejection and abandonment. My story gave me secret passes for bitterness, hurt, and sin.

As a young wife, beginning a family of my own, the weight of those feelings began to crush my spirit.

"Why?" I yelled out to God one afternoon, sitting on a bathroom floor with my head in my hands. "I was a mistake in the back seat of a car. I wasn't supposed to be here!" I prayed as though it was something God needed to know.

It was then, for the first time in my life, I felt words deep in my spirit, "You were not a mistake. You are Mine."

Peace rushed in and bathed my soul with those words.

I had a new story.

I belonged to a Father in Heaven.

He wanted me.

I am here because of Him.

It was then I made the decision to be thankful for the choice my mother made. I would simply be thankful my mother chose life.

My life.

I would be thankful for my childhood. It was safe and relatively uneventful. Growing up in Southern California in the 1960s, my days were spent swimming, skateboarding, and playing in a neighborhood full of young families like my own. I suffered no abuse or neglect. We were the typical "Ozzie and Harriet" family for the early years of my childhood. (You might have to Google that reference.) And yet from a very young age, I understood the only mother and father I had ever known were not my "real" parents. I didn't fit. I wasn't like them.

The only way I could interpret this was in a deep longing for what a family should be.

So I created my own.

At the age of sixteen I married my high school sweetheart. We had our first child two years later.

For years my children begged me to search for my birth family, especially as they grew into adults. They had so many questions about our history, heritage, and genetics. Where did the Robinson traits that were so blatantly obvious to everyone who knew us come from? What kind of medical issues would my grandchildren face? They had no family identity other than the one we gave them. Our family roots felt very shallow.

Even so, every time the question of finding my family came up, the answer was a resounding no. Again. And again. Just no.

That was a door I was terrified to open. Who knew what hid behind it?

What if I was the product of rape?

What if I was a well-guarded secret that is still being kept?

If I made myself known, wouldn't that be extremely hurtful to someone who thought they had fixed the problem of me? After all, she gave me a good life. Shouldn't I respect that? The right thing to do was to keep her secret. There was just too much to lose. Those thoughts remained my frame of mind throughout my adult life.

At least, that is, until Halloween 2017. My husband gave me a birthday gift that would not only change my story but once again shatter my internal world. He gave me a DNA test. It seemed harmless enough. It was supposed to give me just the information to learn my heritage. It would also show what genetic health predispositions I may have. My children would have the answers they were looking for, and I wouldn't have to confront any of my fears.

No lives would be disrupted.

No secrets revealed.

At least that's how I would have written my story. But then, as I found once again, I am not the author of my life or my story.

Within a few weeks, the test results came in. It had all the typical information I was hoping to find, my ancestry and health. Then I read two unfamiliar names at the top of a list of relatives. Under the names were the family titles, *uncle* and *first cousin*. My heart sunk, and my mind went blank.

What I didn't realize until that moment was that when you make yourself available for DNA relatives, you get a list of names and their relationship to you.

Honestly I did not see that coming.

Not knowing what to do, I sent a screenshot to my oldest son Chris who promptly began a search. Within hours, he was in contact with my cousin.

My cousin knew a story I didn't know.

Mine.

Nothing I was told as a child about my origins was true—from the age of my mother to why I was surrendered. The truth not only exposed the lies I was told but also lies I told myself.

Once again my world irrevocably changed. Chris began to tell me the names of my mother and three of my siblings. Over the following days and months, my story began to unfold. For the first time I could see a glimpse of my life story as God had written it. Fear once buried deep inside burst apart in a flood of emotions with my sister's words, "We have been looking for you for years."

My entire world shifted as truth poured into the blank spaces. I was learning my life story as it was written by the hand of a loving Father one line and one page at a time. As I stepped into my mother's family, each one brought the stories of their lives, which took their rightful place within my own.

A few months later the last piece was found—my father. Although I wasn't lucky enough to have found either of my parents while they were still alive, I have found the family my heart longed for.

At the age of fifty-eight, I walked into the open arms of the two families I was born into but not brought home to. My uncles saw the sister they loved, and lost, in a new face. My sisters found the missing piece of their mother's heart they had looked for since they were young. My brother found the kindred spirit that filled the hole he couldn't name. My paternal sister found she wasn't alone in the world after all. I found the rest of me in each of them.

The flood of love, warmth, and acceptance I felt at the moment I met each one I can only imagine is what a newborn experiences when born into a loving family. Just like the first day home with a new baby, each family member searched my face and mannerisms for the common traits that connect us. I was showered with small

gifts that wrote on my heart, "Welcome, you are part of us." No one needed to see the test results to know who I belonged to. What I couldn't have known until we saw each other face to face was that God had given me many of my mother's traits. Without ever knowing her, I carry her with me.

What was once my family's secret shame God transformed into a gift.

At the right point in time.

What I thought was my life story was only a small segment of the puzzle that even my imagination could not paint.

Fear withheld me from looking for them. God knew I needed to have each one in my life. The family he placed me into was restored. The almost instant bonding with my siblings was life changing.

Seeing familiar traits in my brother that I had only seen before in the son I lost was a healing salve on my wounded heart. It made an indescribable connection between someone I've lost and someone I've gained. While my biological family sees the mother, sister, and aunt they lost in my features, I see the rest of my story in theirs. God has given me not one family but three. And from the moment I came back into my family, I have had a sense of belonging that I've never known.

The Bible is filled with people stories. From Adam and Eve to the twelve apostles, their failings, trials, and triumphs are written for a lost world. Their stories help us to understand ourselves and the God who loves us. They allow us to see how God works in the lives of His people. We see their frailty alongside His power. Their lifespan is spread across pages for all to see and help to heal a world plagued by darkness.

Like the stories of the Bible, your story and mine are also filled with frailty, failings, and searching for God's fingerprints. One digital picture frame reminds me daily that we don't know our own story.

If you were to write your own story, would your life so far be how you would write it? Who writes in their own tragedy or heartbreak? Nothing shapes our lives like the events we have no control over and no ability to stop. We want our lives to be happy. But happiness is not something you can buy or chase. It is a by-product of living the life you were designed to live, even when it hurts.

## The Masterpiece of You

In *The Problem of Pain*, C. S. Lewis explains we are a divine masterpiece. He doesn't mean in a metaphorical sense but in a very real sense. We are something God is making and therefore something with which He will not be satisfied with until He has given us all He has planned for us. That's not to mean our wealth or status, although He does care about every aspect of our lives.

Lewis uses the illustration of an actual artist and his life's work. If the artist were going to draw something for a child, he would simply do a sketch. It wouldn't have to have detail or maybe even color to delight him. The artist could do it quickly without much thought or care to his work. He might even look at it and think it wasn't quite what he had in mind at all. But as long as the child is happy, there is no need for him to fuss over it.

The work of his life, his masterpiece, would be a different story. A work he loves deeply, as much as a man loves a woman or a mother loves a child, he would labor over endlessly. To bring forth the image conceived in his mind he would make many sacrifices to see to it that it was complete and perfected. A masterpiece he was proud of and worthy to bear the master's name.

Let's imagine for a moment that the masterpiece the artist was laboring over was sentient. It could feel the many gentle strokes of the pen, the hard eraser rubbing, the scraping and redrawing over and over again. After so much the picture would look at the

imperfect simple sketch with envy. It only took a minute to create. There was no pain in the redrawing of hard lines, no erasing, rubbing, or smoothing of sharp edges. In a way, it's only natural for us to resist the rubbing and erasing as God shapes our lives. If we were to ask God for a less glorious design and less difficult destiny, we would be asking for less of His love—not more.

You are His masterpiece.

## The Pendulum Swings

An old pendulum clock hangs on the wall in my living room. It has been a part of my home longer than most of my children. *Made in Germany* is written on the bottom of its face. That stamp tells the story of a clock made before the end of World War II before Germany was divided into East and West. The wooden body that houses it was made decades later. The past is encased in the new while always pointing to the present.

As the hands move, so do the gears behind it. Like all pendulum clocks, the pendulum swings, moving the gears that in turn move the hands pointing to the current time. Minute by minute, hour after hour, it gives a name to a single point in our lives. It announces each hour with the corresponding number of chimes.

Over the decades, countless nights were spent watching the hands of that clock with excited anticipation timing the contractions with each of my babies. Then there was the day I dreaded its movement. The day of Dan's funeral, when each move of the hand pushed me to a place I didn't want to go.

That clock has marked every significant point in my adult life. Just as it has also whispered moments I've let slip away. Watching the pendulum swing as I wrestled with thoughts of *what if* taught me a lesson in time.

You see, the face of the clock and time it displays is all we notice from day to day. What you don't see are the many gears behind

the clock. Some are large and some are small. Each one is trimmed with hundreds of teeth and grooves. As one gear rolls it touches another. As they mesh it forces the other to turn. When it does the same thing happens again. Another gear is touched and turned. In the process of turning, each tooth of one gear locks into the groove of another. For an instant they are perfectly fitted, and then it's gone, on to another. Each movement carries the hands just ever so slightly a little bit further. Turning the future into a brand new now. Throughout the day I check its face to see where the hands are pointing. What we don't see are the thousands of connections it took to bring that hand to the one instant in time.

When the unthinkable happens your mind and your heart race in different directions. As your heart sits upon your chest leaving a raw gaping wound, your mind tries desperately to stop the pain. We search for a point in time that if we insert a different action we could have changed the chain of events.

Sometimes it's true. Other times it's not.

I can still see Dan's overgrown blonde bangs swing over his eyes as his head dropped with disappointment the morning of the accident when I told him he couldn't go with us to the hospital. My oldest daughter Jami replayed her words that made the boys stay several minutes longer than they planned. Each one of us had a point in time that if we could have turned back that clock, it would not have happened. The logical conclusion that each one of us has had at one point or another is—*it's my fault*. My oldest son who had given his brother the truck they were in, the brother who was driving, the parents who said no, the sister who created a slight delay—we all searched for that moment in time we wish we could change to alter the course of events. A moment when we could turn the hands of time back. If that moment were turned back, the hands of time wouldn't strike tragedy.

To turn the clock back means these gear points must also turn back.

To wish for the hands to turn back from one point in time—the one we see—is to turn back the hundreds if not thousands of connections it took to come to that point.

Just as for every strike of the clock there are thousands of connections, peaks, and valleys laced along the edge of the gear, so too is your life. Each point in time was created by thousands of small, seemingly insignificant events—large and small gears, large and small events.

I've thought over and over about what my life would have been like without the single point in time when my mother relinquished me. If she had been able to tell my father I existed. A thousand points of contact were also created before and after relinquishment. Many lives were irrevocably altered.

To change one point in time is to change thousands.

We like to think we can write our own story. Create our own destiny. Make our own success. That is only the reflection of the free will God has granted us.

## Pain Always Accompanies Birth

Some family members had no idea I existed, and they felt bad—not of my mother or of me but rather the decisions that were made for me and us in secret. That I had been lost to them for so long. That my mother carried a hidden wound to her grave.

Many of us struggled with the *what ifs* as the shock wore off and the ramifications began to surface. Missing pieces not only of my puzzle but also of my mother's were found. But in finding them they also revealed other missing pieces. A generation no longer with us couldn't give us the answers we looked for.

When life-altering events happen, we would give anything to turn back the clock and go back to the world that once was rather than face the world that is.

We imagine what it would be like today if we could rewrite our stories. We want to turn back the hands on the face of the clock without thinking about how many gears must turn with it. How many new events would then be created and lost?

God does not exist to do the bidding of man. Man does not exist for himself alone. Revelation 4:11 says, "You created all things, and by your will they were created and have their being."

This is where trust comes into play. God can be trusted. The one who created the universe is writing your story. As you sketch your life and draw hard lines, He erases and draws new ones. Where once was only black and white, He washes in shades of gray. The Artist who paints the sunrise and sunset is painting your story with the vivid colors that only He can see at the moment but will one day reveal in vivid color.

C. S. Lewis wrote in *The Problem of Pain*, "We were not made primarily that we may love God (though we were made for that too) but that God may love us, that we may become objects in which the Divine love may rest 'well pleased.'"

We can't write our story. We are at the center of a divine love story, one that is ever changing, becoming ever more beautiful. When we find beauty in our imperfections, it gives God the room to create in us what He deems pleasing perfection as He creates inside us His masterpiece.

## Fragments of Reflection

There is an immeasurable amount of forces working around us that we have no idea exist. Events that happen in our lives while we were infants still impact us. The lives our parents led before we were born play a part in who we are. When we can accept the fact that there is far more to our lives than the moment we live in, only then can we let go. When we can let go of our belief that we can

control our lives, we find the freedom to trust. We can trust that no matter what the sunrise will bring, we have a God who loves us enough to make us shine alongside it.

## Be Still

As you breathe in the holiest name in the universe, lift your head toward heaven. Then bow your head in the knowledge that you are His masterpiece.

## Your Story

Without ever uttering the words, I once held a secret belief. I believed that if I was a good Christian mother and taught my children to love God, they would not fall into sin. They would be safe. I wanted to keep them from all pain and suffering. I believed if I was a good person, I would be protected from tragedy. When reality struck less than ten miles from home, its equal and opposite impact stood me emotionally naked before God.

> As the deer pants for streams of water, so my soul pants for you, my God. My soul thirsts for God, for the living God. When can I go and meet with God? My tears have been my food day and night, while people say to me all day long, "Where is your God?"
>
> —Psalm 42:1–3

In spite of the fact I have been a Christian since I was sixteen years old, it wasn't until I stepped into this new world of grief that I understood that passage. The psalmist didn't write those words in times of peace and plenty.

My God, my soul is in despair within me; therefore I remember You from the land of the Jordan and the peaks of Hermon, from Mount Mizar. Deep calls to deep at the sound of Your waterfalls; all Your breakers and Your waves have rolled over me. The LORD will command His lovingkindness in the daytime; and His song will be with me in the night, a prayer to the God of my life.

—vv. 6–8 NASB

Deep does indeed call to deep. Just as the depth of love calls to the depth of grief so too is the depth of your need to seek God's face and the depth to which you will find Him. The law of fierce opposites is in your favor.

If in fact I was right and I could be a good enough mother to keep the sins of the world away from my children, there would be no need for God to send His only Son to die for their sins—or mine. If I could keep tragedy away there would be no such thing as "deep calling to deep." The truth is I do need a Messiah. And our Creator sent one to me. He sent Him for a dying world—of which you and I are a part of. We have seen its pain up close.

For the first five decades of my life, I thought I could write my own story. I thought I could create my own destiny and be anything I wanted to be. I just needed to try hard enough. Happiness gurus tell us, "Write your own story," and, "Create your own destiny." There are truckloads of slogans selling the illusion of control—over your circumstances, over your life. Control has become a profitable product, and high prices are paid. The idea is that you can make your life happy by controlling it. But you and I know better. That's not how real life works. That's not how any of this really works.

When forces beyond your control pull that illusion right out from under your feet, sending you falling backward off a cliff, what do you grasp on to? I spent many years free falling off that cliff. Free

falling with nothing to grasp on to except the knowledge my God loved me even within my deepest pain. The foundation I built with my own strength and my own hands crumbled under my feet. In its place now is one that can't be shaken or cracked. It is a foundation of trust. I trust that the unseen hand of God is underneath me, guiding me always.

Know that you are loved and His hand is underneath you as well. I know there are still pieces of your life you have yet to find. Your story is different from mine of losing a child and discovering a family. Your story is uniquely your own and cannot be compared to the stories told in this book. What they illustrate is we are all masterpieces still under construction—no matter the current circumstances. Don't be afraid to trust the unseen hand of God to find the pieces He designed for you. They will fit perfectly into your beautifully imperfect life.

The pieces of the puzzle of your life will find their way to form a new picture. It's not the one you thought you had, rather it's the one God imagined. This is not the end. He is the author of your story; you are His free-falling hero.

## Prayer

Father God, You knew me before the foundations of the world. You saw me in my mother's womb. You had a plan when You designed me. With each sunrise that greets me, Lord, I will sing Your praise. I will thank You for every circumstance that befalls me because I know that whether I am standing on a mountaintop or walking into a lion's den, You are with me. You will never leave me. You have heard my cries and counted my tears. Wipe the tears from my eyes and restore my heart. For You are the Great Physician. The healer of my soul.

# SUNRISE

# REFLECTIONS

# Sunrise Reflections

Trust in the LORD with all your heart and lean not on your own understanding; in all your ways submit to him, and he will make your paths straight.

—Proverbs 3:5–6

The pieces of my life puzzle were found and placed within the pages of my Sunrise Reflections. Over the course of the last ten years they have evolved from simple stream-of-conscious writing to journaling to finally my Sunrise Reflections and Life Sketching system. In all of that time, only a handful of days were started without this daily routine. On days when there was something to do or somewhere I had to be first thing in the morning, I would get up an hour early to make time. Most of the exceptions were because of staying up all night with a laboring daughter or taking an overnight flight. My commitment hasn't been because I am naturally studious. Far from it. By nature I'm much more of a free spirit. But the system I'm about to share with you has literally saved my life. I have used this system daily for the last ten years because it has been my lifeline. Through the scribblings on these pages I have been able to clear away the mental clutter and hear the Holy Spirit over the torments of my broken heart.

It's commonly believed that it takes twenty-one days to create a habit. So the next section gives you a twenty-one-day launch pad. After the first twenty-one days are up, your Sunrise Reflection

and Life Sketching time will become a habit. But don't stop there. Commit to another twenty-one days. According to Dr. Caroline Leaf, the next twenty-one days will create new pathways in your brain. By continuing, the thoughts and patterns you have created through your writing will become part of your DNA.

You are not just creating a journaling habit. Creating a new habit is just the beginning. What we are looking for is real life-changing, soul-searching, healing results. You are renewing your mind and spirit. All of which comes from allowing your subconscious to wrestle your reasoning mind and pin it to the mat so it can be renewed. Although the renewing of the mind begins as a spiritual endeavor, it is also a physical exercise that changes the thought patterns in your brain.

Learning to trust your intuition can be difficult. It's really not something most of us are taught as children. We are taught and encouraged to use our reasoning mind. Its voice is the most dominant. When your intuition speaks to you, oftentimes there is a second voice that comes right behind it, discounting the first. That is your reasoning mind overriding your intuition. Another way to say it is that your carnal mind is silencing your spirit. While you're writing your daily reflections, listen for that quiet voice. Listen for your God-given intuition. That is your spirit speaking to you. Write it down. Give it a voice.

# How to Create Sunrise Reflections

## Something to Write In

Begin with two journals. One will not be used or read again, the other is your blueprint for healing. This can be done in several ways. Rather than using two separate journals, I have actually used one journal by writing in the front, then turning it upside down and writing in the back, making two books in one. Or you can use a divided spiral notebook. The thing is not to let your idea of just the right tools stop you. These are just tools. You don't need an Italian leather journal with rosebuds burned into it. Unless, of course, you have one laying around. The real product is inside you.

## Pens

One thing that has amazed me is how fast I can run out a pen. My theory is pen makers count on me losing it before it runs out so I'll never know how little they put in it. The longest-lasting pen I've found is the Pilot G2; personally, I enjoy writing more with the .07 size. But that is a personal preference.

## Thirty Minutes of Quiet Time

Thirty minutes is sufficient. At least most of the time. You may find you want more. If you set a timer for the allotted thirty minutes, it

can alleviate the stress of feeling as though you are wasting time or it has been too long and you need to be more productive elsewhere. This is an important part of the day, but our reasoning minds tend to keep us on a short leash. It takes some time for it to allow your spirit the time it needs.

## Start with Your Routine

We touched on daily routines in chapters 7 and 8. Now is time to really consider what those look like in your life. Everyone has them. Only not everyone is intentional in the way they do it. I'm asking you to be intentional. To think about your morning routine and prepare for it the night before.

I make sure there is water in the teakettle and my journals and pen are in the spot I'm going to sit in. All I have to do is boil water for my tea and sit down to write. I curl up at the corner of my couch with my journal, a cup, and and a small teapot filled with my current favorite tea. I write in my pajamas. Over the years there have been slight variations. Overall, it has stayed pretty much the same so that this practice is my autopilot.

If at all possible, get up before the sunrise or at least in time to see it. Don't miss the majesty and the power of the sunrise.

## Sunrise Reflections

First, pause and breathe the name of God. Take five slow, deep breaths, lifting your face to heaven with an inhale and bowing in thankfulness with your exhale. Two very important things happen here spiritually and physically. By taking in these deep breaths you are oxygenating your brain. The life-giving oxygen will help revive your mind. You are acknowledging God as you consciously utter His name with your breath.

This is about trust. "Trust in the LORD with all your heart and lean not on your own understanding; in all your ways submit to him, and he will make your paths straight" (Proverbs 3:5–6).

This puts your own understanding aside, acknowledges Him, and allows you to watch Him make your paths straight. The New King James Version translates Proverbs 3:5–6 this way, "Trust in the LORD with all your heart, and lean not on your own understanding; in all your ways acknowledge Him, and He shall direct your paths." I've found this translation to be exactly what has happened in my life; as I searched for direction, he directs my path.

After you have acknowledged him, begin to write. Within the first thirty minutes of getting up, sit down to write while your brain is still a bit foggy. Date your page and begin to write in stream-of-consciousness form. Write whatever comes into your conscious mind. Anything. Everything. What you are doing is dumping your mental mess onto the paper. This is where you take out the trivial trash that pollutes your mind. The daily to-do list, the chores, the conversations, whatever is on your mind. Begin here. Once the trash is taken out, your conscious mind will start to bring things up that it is holding on to for you.

## Beware of Mental Hoarding

Have you ever seen the television show *Hoarders* or known a hoarder? Their homes are so filled with clutter there are only pathways to walk through the house. The drapes are always closed. Every flat surface is covered, including most of the furniture. Walls of boxes, books, and clutter line the paths through the house. There comes a point where the hoarder can no longer tell the difference between garbage and treasures. All of the clutter becomes treasures, so all of the treasures become trash. The garbage takes over. This happens in your mind as well.

Holding on to the hurts and toxic thoughts create the same state of clutter in your mind. Storing these thoughts and not releasing them is the same as holding on to physical clutter. You hoard them as though they are treasures, and they become noxious to your spirit and body.

Consider for a moment a time when someone offended you. Did you respond in the way you wanted to? Or did you just rehearse what you now consider the correct response in your mind? Then you dropped that thought right where you left it, somewhere tossed in the back of your mind.

The daily routine of taking out the mental trash clears the pathways for more important thoughts. The pathways in your mind become wider every day until they aren't pathways at all. Even a well-fed spirit that is mature in the Lord can sometimes not be heard when there is mental hoarding. Your unconscious mind can communicate with your spirit. When your mental clutter is cleared away, your spirit takes the lead, and your pen becomes the tool of the unconscious mind. It gives it a voice.

As you continue to write and the clutter is cleared it gives way to the conscious, then the subconscious mind bubbles up to the surface. By giving your subconscious a voice, your paper becomes a platform for your conscious and subconscious minds. Those thoughts need to wrestle and untangle the issues that tie the hands of the Holy Spirit within you. Ask questions that plague you. You will be surprised how clearly the Holy Spirit will answer you.

Again, you are writing longhand, with a pen, a minimum of three pages or thirty minutes of continuous writing. End in words of praise and gratitude. Find and write about three things you're thankful for. Always begin with acknowledging the Lord, and end in gratitude.

Learning to trust your intuition can be difficult. It's really not something most of us are taught as children. We are taught

and encouraged to use our reasoning mind. Therefore that voice is the most dominant. When your intuition speaks to you, oftentimes there is a second voice that comes right behind it, discounting the first. That is your reasoning mind overriding your intuition or spirit. While you're writing your reflections, listen for that voice. Listen for your God-given intuition. Write it down. Give it a voice.

## Let Sunrise Reflections Cast the Perfect Light on Your Life Sketching

This is the fun part. Go back and highlight anything that was profound or instructional. Did you receive insight into something? Or a thought that needs to be considered in more depth? Perhaps as you were taking out the trash you realized there is something you are forgetting to do. Put all of this in a separate journal. This is your Life Sketching journal.

As your daily sunrise reflections unfold, you will find they give way to a clear path as God makes your way straight.

Every action begins with a thought. Oftentimes those thoughts are shot down in our own minds before they can take root. But something almost magical happens when you put the same thoughts on paper over and over. You can watch the inner struggle between will and spirit fight for control. In the end, given enough time, the spirit gains strength and always wins.

One simplistic but practical example of a struggle I've had that impacts my daily life is caring for my health. Many mornings of my complaining in my reflections include how bad I feel, how my body hurts, and how I need to change some of my bad habits. When I get too heavy the pain gets bad. I know how to fix it. Eat a healthy diet. However that takes a certain amount of will power I'm not naturally endowed with. For months I wrote about my need to

change my eating habits. When it came time to make something or grocery shop, my reasoning mind talked me right out of it. Pasta meals are cheaper. I'll do it next week. I can't start until I create a menu plan. So it just didn't happen. The diet my doctor gave me for inflammation looked like a starvation diet—at least those were the thoughts going through my mind.

Then overnight everything changed. The diet wasn't a bad idea. I could do this. I wanted to do this. I went on my prescribed diet without any struggle. What happened? I had written about my need for so long my subconscious mind rewired my thought patterns. Over and over this has happened through the years. Something I would struggle with would suddenly become as natural as breathing. The battle always begins in the mind. Thought patterns are entrenched. Through daily writing and allowing your spirit to bubble up and rewire your thought processes, you are renewing your mind—spiritually and physically. As these thoughts pour onto the paper, the plans God has for your life will come into focus. The story of you will unfold, written and directed by the Creator.

Capture the thoughts and visions and put them into the back of your journal or into a second journal. This is your Life Sketching journal. Day by day the pieces will start coming together. This is the journal the Holy Spirit is writing. In it, He will give you the next steps in God's plan.

Not the entire plan. Only the next steps.

Remember the dark rooms we talked about in a previous chapter? Daily writing in these pages will amaze you as you watch God flip on the lights for you. Your twenty-one days of journaling will become a habit, renew your mind, and ultimately renew your life. As your Sunrise Reflections shed a heavenly light on your Life Sketching, the masterpiece of you will unfold under His hand.

# 21 DAYS OF

# SUNRISE

# REFLECTIONS

# Day 1:  What Time Is It?

There is a time for everything, and a season for every
activity under the heavens.

—Ecclesiastes 3:1

*Y*ou, Father God, set the morning star in its place. You are the
same today, yesterday, and forever to come. The seasons
change by Your command. Nothing stays the same. Still,
Lord, my heart yearns for the world of yesterday. To see the faces
of laughter, to feel the sun on my face without pain in my heart. I
fear time has frozen and I will stay in this winter. This winter of my
soul. I long for what I cannot have—a season past.

And yet You call the spring flowers to break through the
winter's snow and lift their faces toward the sun. The stars pull the
ocean tides to churn time toward another season. I know my life
has seasons too. My life, heart, and soul are not exempt from the
solitude of winter. I will not stay in this season of darkness forever.
I feel Your fingers on my chin lifting my face toward Your Son. I
will lift my head to the warmth of Your healing light. Like the flower
that blooms in the snow, I will burst forth out of this season with all
the life You have given me.

## Sunrise Reflections

Can you look over past years and see the path you have forged?
Your journey down that path is your life story—so far. The future is
not going to be the same as it is today. But how it looks does build
upon what you do today. What time and season is it? Is it a time to
mourn? A time to tear down? Or a time to heal? It may not be the

time you think it should be or the time you want, but it has purpose. As you write this morning, ask the Lord *what time is it?*

> He has made everything beautiful in its time. He has also set eternity in the human heart; yet no one can fathom what God has done from the beginning to end.
>
> —Ecclesiastes 3:11

## Be Still and Know

The bareness of winter is always followed by the beauty of spring. The light always overpowers the darkness. He has set eternity in my heart. God is making my story beautiful.

## Day 2  Strength of Another Color

The LORD is close to the brokenhearted and saves those who are crushed in spirit.

—Psalm 34:18

can't pretend any longer, Lord. I am not strong. Like a fine china plate smashed on the ground and stomped into fragments—I am broken. I don't want anyone to see my brokenness. I don't want the starkness of my pain to break them too. People think I am strong. I'm not. I'm hiding. I can't pretend with You, God. You know my inner thoughts. You know my heart is broken and my spirit is crushed. I want to crawl up on Your lap like a child and stay there.

My pain draws You near. I will not push You away. I need to feel Your presence like never before. I know You are here. Right now. With me. I can feel Your compress of peace pressing into my heart. You call my soul to You. I feel it drawn into you as You draw closer to me. Lord, I have no room in my heart for anything other than Your healing touch. The heaviness of my heart can only be carried with your strength. Remove from me any bitterness and unforgiveness. Keep strife far from me. I don't have room for these poisons in my life anymore. All I have room for is the pain in my chest and the healing power of Your peace. This is my life. You show me what true strength is. I will stand and look suffering in the eye and embrace it. Because Your arms are around me. You fill me with a joy that gives me strength. My strength comes from the touch of Your hand as You reach for mine.

## Sunrise Reflections

It doesn't take strength to pretend. Real strength comes from pressing into the pain while allowing God to dress your wound. When you can lift your face toward heaven and speak words of praise through tears, He will anoint your forehead with the oil of joy. You won't have to paint on a fake smile or pretend to be strong. Your strength will not come from your own power. It will come from the Holy Spirit when you're weak.

Are you leaning into the pain you feel? Or are you pushing it away?

> When they walk through the Valley of Weeping, it will become a place of refreshing springs. The autumn rains will clothe it with blessings.
>
> —Psalm 84:6 NLT

## Be Still and Know

My God walks with me, and He will give me the strength to face this day. It doesn't matter what it will bring. He will make for me pools of blessings. I will praise Him in the rain, and He will clothe me with the strength of joy.

# Day 3: Treasures in the Dark

I will give you hidden treasures, riches stored in secret
places.

—Isaiah 45:3

The dark places of my soul, Father, feel so far from You. And yet at the same time I can feel Your breath still within me. So many voices around me saying I must not remain in the darkness. Yet this is where I belong right now. Happiness is not within my grasp. I only want to collapse into Your arms, press into Your chest, and feel Your arms around me. I'm not afraid of the dark. Darkness and tears have become my friend. I am alone, even with many people around me. My soul is in solitude. I don't have the strength to fight off the heaviness that surrounds me. I don't want to fight it off.

You give me the strength to stay in the darkness of grief. You are with me in my pain. You feel it too. Because I know You are beside me, I know You will lead the way out. The rest of my days will not be marred by this dark time. You will show me the treasures hidden deep in the dark. Allow my eyes to see what You have for me in this place. The strength I receive is from your Holy Spirit. That strength tells me to live. To face my pain another day. To press into it and feel it for all its fury. Because that is what was true. But it is also true You hid riches in secret places. They are not for those who don't know You. They are for those who call on Your name. You light the way out of the dark, Lord, and I will follow You. My heart is full with the treasures You have revealed.

## Sunrise Reflection

There is beauty in the darkest night sky. Like a blanket of black velvet studded with diamonds spread over the earth, the heavens glimmer and show off their splendor. There is strength in the darkness that is hidden in the daylight. Have you asked for the strength to sit in the darkness and find the treasures the Lord has hidden for you there?

## Be Still and Know

Darkness always turns to light. The darkness does not rule the earth. Jesus is the morning star, and yet He's not hidden even in the darkest night. His light is always present. *My hand is open, Lord. You have riches and treasures for me that I will carry out of this darkness with me.*

## Day 4:  My Inheritance

Peace has been stripped away, and I have forgotten what prosperity is. I cry out, "My splendor is gone! Everything I had hoped for from the LORD is lost!" . . . I will never forget this awful time, as I grieve over my loss. Yet I still dare to hope when I remember this: The faithful love of the LORD never ends! His mercies never cease. Great is his faithfulness; his mercies begin afresh each morning. I say to myself, "The LORD is my inheritance; therefore, I will hope in him!"

—Lamentations 3:17–18, 20–24 NLT

*E*verything I had hoped for in the Lord is lost!" I know that feeling. I probably said it out loud, though maybe not so poetically. Nothing mattered. Nothing. Everything I once loved and laughingly believed defined who I was all melted into a pile of contempt.

That was when the vision of my life was thrown to the ground. It's also the very moment when I come face to face with the realization that I have absolutely no control. Circumstances beyond my control marched in and changed my life without apology. Not only will I never forget this awful time, but it is also a marker in the timeline of my life. There was life before and after. One event split my time continuum beyond repair. Why didn't the earth shake or the stars fall from the sky? Oh, but they did. Only no one could see. It was my inner world that shook to its core. I remained a prisoner trapped in an earthen body hosting a tattered heart.

And yet His mercies come in drops like rain. An unexpected burst of laughter with tears still wet on my cheeks. An unexpected

kindness from a friend long forgotten. God, Your compress of peace presses against my wounded heart. Your mercies are new every morning indeed. Your love is faithful and restores my soul. In You I dare to hope for a more beautiful sunrise tomorrow.

## Sunrise Reflections

The pain of yesterday is locked away in a memory. Do you hold the pain like a treasure? Or do you let it give way to hope? Humankind has always built monuments to mark an event in time or a victorious battle. What about the battles of the soul? Headstones mark graves. But what marks the death and resurrection of a broken heart? What is the monument that marks the change in your life that says *it stopped here*, but now everything is made new?

## Be Still and Know

The Lord is my inheritance. His hope and loving-kindnesses are fresh and new today. From this day on, I will lean into the hope of the Lord. He is faithful. I am His.

## Day 5: Peace for the Weary

And the peace of God, which transcends all understanding, will guard your hearts and your minds in Christ Jesus.

—Philippians 4:7

Grief siphoned my physical strength and drained it onto the hospital floor. I could feel it go. With my head resting on Mike's shoulder and while staring at the floor I imagined my strength flowing out of my body, through an invisible tube, and pouring down the metal drain before me.

No one ever told me grief was so exhausting. The simplest tasks seemed insurmountable. Sleep was no longer a problem. Wanting to wake up was becoming a real issue. It was our thirty-second wedding anniversary. We spent the entire day sitting on the unyielding metal chairs that lined the hospital walls. An enormous amount of glass was still embedded in Tommy's body. The pieces, large and small, were supposed to "work themselves" out. There was just too much.

A friend came to sit with us. She was at a tipping point in her son's life. He was all but lost to her. While we were rushing into the storm in search of our boys, she was standing in the rain, trying to convince her son suicide was not the answer he sought. We sat together for hours while the doctor dug chunks of glass from my son's neck. We sat mostly in silence, feeling each other's torment.

The peace God brings is a warm blanket that smothers out the fires of fear. When my soul is weary with sorrow, You, oh Lord, strengthen me with Your peace. It engulfs me with a calm, quiet strength to face the unthinkable. I stand before You in my

weakness. My soul is naked before You, dripping in sorrow. You dress me in Your strength because I have none of my own.

It's in the incomprehensible peace that You bring that makes me know You are near. I will keep my trust in You because You keep me close. I will not allow my mind to step away from Your peace.

## Sunrise Refection

Are you exhausted? Is your soul weary from fighting the circumstances that want to swallow you? Jesus said, "Come to me, all you who are weary and burdened, and I will give you rest" (Matthew 11:28). Steal grief's siphon hose and use pencil and pen to drain your burdens onto paper. Release them into the hands of Christ, and allow Him to give you the rest that brings strength and, above all, hope.

## Be Still and Know

Isaiah 40:29 says, "He gives strength to the weary and increases the power of the weak." Because I am weak and weary, my God strengthens me in new ways every day. He infuses me with the power to face the sunrise with steadfast trust in His peace.

## Day 6: How Long, Lord?

How long, Lord? . . . How long must I wrestle with my
thoughts and day after day have sorrow in my heart? . . .
But I trust in your unfailing love; my heart rejoices in your
salvation. I will sing the Lord's praise, for he has been good
to me.

—Psalm 13:1–2, 5–6

Time seems as though it goes on for eternity. The now is so
fleeting and yet seems so permanent all at the same time.
The days drag into nights, and the nights hold no rest.
My thoughts attack me when I am not yet fully awake or asleep.
My body is here, but I am not. I feel like a shell, a heavy-weighted
shell filled with regret. Shame wants to sneak in the back door of
my mind. My own thoughts torment me while my heart cracks. I
wrestle thoughts of guilt. I try not to let them in, but they ride in
on a tide of sorrow. *This is all my fault. If only I had . . .* The whisper is
soft, and it sounds like my own voice. I know they are lies. I know
those thoughts are stepping-stones to the depth of despair. I will
not go.

When thoughts of hopelessness invade, I will not allow it to
take root in my mind or live in my heart. The love my God has for
me cannot change. He whispers to me, "You are Mine." I will lift my
voice to You. I will lift my face to the light of Your goodness. You are
good. You are the God who knows my inner thoughts. You are the
God who lifts my chin and wipes my tears. In You alone do I trust.
Your joy fills my emptiness and sweeps out the lies. I will sing to
You my songs of sorrow and of joy. I will say out loud that You are
the God who restores my soul.

## Sunrise Reflections

Are you wrestling with your thoughts? Where are they coming from? Tell the Lord today about the lies coming into your mind. Give Him a place to bathe them in His truth.

## Be Still and Know

Second Corinthians 12:9 says, "But he said to me, 'My grace is sufficient for you, for my power is made perfect in weakness." Therefore, I will boast all the more gladly about my weaknesses, so that Christ's power may rest on me."

Christ sees my weakness. He knows my inadequacies. His grace has them all covered. I will keep my mind on the Lord whose love, power, and grace rests on me, and I rest in them.

# Day 7:  What Am I Afraid Of?

So do not fear, for I am with you; do not be dismayed, for I am your God. I will strengthen you and help you; I will uphold you with my righteous right hand.

—Isaiah 41:10

I thought I had it all figured out. I thought I was being good. I thought evil could not befall me because I am Yours. I woke up this morning and saw my life has changed. Nothing feels the same. There is a heavy lump in my chest where my heart once was. I'm afraid this is the way my life will be forever—marred by tragedy. The looks of people's pity haunt me. I don't want them to feel sorry for me. I want them to not see me but rather see You. You are with me.

I will not look at my troubles and ask where You are in the midst of them. You are my God. I know You are here with me. Today I will pick up a piece of my life and smile. I can smile because You give me the strength to stand. You help me up. I can see the light of your righteousness. It leads me to Your perfect peace. No anxiety can hold me because I belong to You. Jesus was tempted. I am tempted. I have Your words to fight temptation when my own fail me. The thief comes to kill, but You came that I may have life. The enemy of my soul has hurt me. But You have come to heal me.

## Sunrise Reflections

Where does your strength come from? Are you putting your faith in something you are doing? Or maybe something someone said? Have you sought out ways to see the hope and help God has

already given you? Have you seen His fingerprints? The Bible tells us we must know that all things work together for the good of those who love God. It is His plan and His hope for you to not be dismayed, that He will uphold you and strengthen you. Where have you seen this in your life already? What has He brought you through before now?

## Be Still and Know

He is my God. I am not afraid. I will not grow tired because He promised to give me His strength. God never fails me. I will not fail to see His hand in my life. His unseen hand lifts me above my trouble, sorrow, and pain. His steadfast love sustains me in the storm.

## Day 8: The Masterpiece of Me

"For I know the plans I have for you," declares the LORD, "plans to prosper you and not to harm you, plans to give you hope and a future. Then you will call on me and come and pray to me, and I will listen to you. You will seek me and find me when you seek me with all your heart. I will be found by you."

—Jeremiah 29:11–14

You knew me in my mother's womb. You looked at my fragile form and smiled. I am Your creation. The dreams and hopes I have for my children pale in the face of what You plan. My dreams for myself are all but lost. I can't see tomorrow through my tears. Everywhere I look, I don't see a future. Everything that once brought joy now brings pain. My plans have all become dust. How can I plan a life I don't want to live? You have also made plans. Plans formed within me before my birth.

You, Lord, have plans of prosperity and goodness. As You fashioned me You knew what my life would hold. Nothing has come as a surprise to You. Nothing. I will look for You in every situation. I know You have plans to do good for me and would never harm me. My heart rests safely in You. This day I call on You, Lord; I call on You to see my life and where my plans were once so important, know that they are no longer. I want only Your plans for my life. Only the goodness that can come from Your hand. It will not corrupt or turn to ash. I want to find You with my whole heart. Open my eyes to see Your provisions and plans for my life.

## Sunrise Reflections

If you could do anything with the guarantee that you would not fail, what would you do? Is there a vision on your heart that God has written by His own hand? Are you afraid that it is your own desires and not His because it seems too good to be true? Write your life from this day forward, how you want it to be. Did you hear God's whisper?

## Be Still and Know

I am a masterpiece of the Creator of heaven and earth. Where I am flawed, He pours in His grace. He has a plan for my life that I am perfectly and wonderfully made to bring to completion. No one else can take my place.

> For we are God's handiwork, created in Christ Jesus to do good works, which God prepared in advance for us to do.
>
> —Ephesians 2:10

## Day 9: There Is a God, and I'm Not Him

For now we see only a reflection as in a mirror; then we shall see face to face. Now I know in part; then I shall know fully, even as I am fully known.

—1 Corinthians 13:12

*I* thought I knew who I was. I created a world around me to reflect my life and everything I love—my children, my home, what I believe. I believed I was walking in Your will because I tried to be good—a good mom, a good friend, a good church member. But I'm not really good am I, Lord? I am fragile and broken. Good really never had anything to do with it after all. Anything that has befallen me has been endured before me by people much better than I. The rain falls on the just and the unjust. I am not exempt from the sorrow of this world. If You make the most beautiful roses bloom in the desert, You can make me bloom in the rain.

You, Lord, know fully what this seed I call my life truly is. You alone know what fruit I am capable of bearing. My circumstances did not change who You created me to become. They cause me to grow in You into the person You fully know I will one day become: the person who stands in front of Your throne. The mirror I view myself in is not true. It is filtered with my own faulty beliefs. When I can see myself fully as You see me, will I be amazed? Yes. I am your handiwork. Who will not be in awe over the works of Your hands?

## Sunrise Reflections

Have you ever wondered just how well you know yourself? I really hadn't. I thought I knew myself really well. Truth is, I only knew what I believed. There's a different concept to contemplate.

Looking back on a life marred by so much sorrow, Corrie ten Boom said, "You can never learn that Christ is all you need until Christ is all you have." Have you let go fully of your image of what your life is?

## Be Still and Know

God sees me as who I was created to become, not the circumstances that surround me. My imperfections don't offend Him. He is not finished with me. I will one day stand before the throne of grace and be fully known. Not as I see me but as my Creator sees me through the filter of His Son and the love He fashioned me with.

## Day 10:  My Garden or His?

We also exult in our tribulations, knowing that tribulation brings about perseverance; and perseverance, proven character; and proven character, hope; and hope does not disappoint, because the love of God has been poured out within our hearts through the Holy Spirit who was given to us.

—Romans 5:3–5 NASB

My life is like a garden full of weeds. There are the roses, honeysuckle, and sage I love and have cultivated. They bring me joy when I see the morning dew dripping off their petals. The weeds have their own deceptive beauty. Some have odd little flowers of their own. Others have hidden powers of healing tucked into their leaves or flowing in their stems. The ivy has vines that weave its way around the flowers. They are pleasant to look at. Their leaves are pretty, and their vines are dainty. But they have gone their own way. The vines have crawled up the stems of my roses and wrapped around the necks of the new buds, choking them and bringing them to the ground. Seeds planted by the birds and the wind all claim their place in my garden.

The weeds of my life also threaten to choke out the beauty I so carefully planted. My garden takes perseverance, long hours of labor, and the outpouring of my love for it to not leave it to its own demise. So too, Lord, is my own life. There are both weeds and flowers I did not plant. Among them are plants that have yet to show their beauty and their unique powers to heal. I will tend the garden of my life well, Lord. I will persevere through all the weeds of sorrow, trauma, and trials. They will not choke the beauty from

my life. Because my hope is in You. My hope is in the love You have for me. The love You have for me shines brighter than the sun and brings healing rain.

## Sunrise Reflections

Have you ever noticed how much detail the Lord puts into butterflies, dragonflies, and the lowly caterpillar? And these are just insects man thinks nothing of. He smashes it under his foot without a thought. They are infinitesimal in the grand beauty of all creation. It is a reminder that God pays attention to every single detail of his creation. How much more does He pay attention to our inner lives, the beauty of our souls He created to dwell with Him in the heavens. Have you ever considered your place in creation? What details has He painted on your spirit that may be in danger of being overrun with weeds?

## Be Still and Know

The Lord satisfies me in the morning. His joy fills me and sweeps away the sorrows of the storm. His morning light reminds me His love is poured out in His Holy Spirit.

## Day 11: Twilight Always Surrenders to the Morning Star

In the morning, LORD, you hear my voice; in the morning
I lay my requests before you and wait expectantly.

—Psalms 5:3

There is a time just before the dawn when my body is asleep but my spirit lies awake, defenseless. The voice of condemnation creeps in and whispers lies and half-truths into the ears of my soul. It torments me with visions I cannot change. With dreams that come in the night and leave me with tears on my pillow. Sleep is no longer a refuge for me. Sleep has become an unguarded pathway for the enemy of my soul to attack my spirit. My mind hears my soul crying and wakes me.

You are my morning light, Father. As the sunlight peeks over the horizon, my tears fall into Your hands. It's now, when the stars are still in place and the morning shows her first light, that You hear my voice. You wipe away the tears of the night. You fill my heart with Your unwavering love. With Your love comes hope. The new day holds hope in its outstretched hands. My hope is in You. I will sing louder than the morning birds of Your goodness and power. You are my redeemer. You are my strength. I can be glad all my life because You and You alone sustain me. My enemy has no power over me. He is nothing more than the howling wind, a voice with no power. Thank You for the joy You restored in my heart as I sing Your praise in the morning along with all creation.

## Sunrise Reflections

There is a space between night and morning where the enemy of our souls roams the earth looking for whom he can devour. This is

a vulnerable time of day. But God does not leave you defenseless. There is power in your will to praise the God of the universe. As you lift your voice to the heavens, the enemy flees. God hears you. How are you fighting the attacks that lift themselves above the knowledge of God's love and grace for you?

## Be Still and Know

The God of all creation hears my voice. Like a mother knows her own baby's cry, so my Father knows mine. I will seek Him in the morning, and He will hear me. I will lift my voice to heaven, and He will fill me with His joy. All of my days will be filled with thankfulness because of His loving-kindness for me.

# Day 12: I Trust in You

> My life is consumed by anguish and my years by groaning; my strength fails because of my affliction, and my bones grow weak. . . . But I trust in you, LORD; I say, "You are my God."
>
> —Psalm 31:10, 14

Trouble wants to follow me. I can't hide from her. She waits for me, hiding. She sees me coming, and in an instant, she throws sorrow in my path. My eyes are so full of tears I can't see the way home to You. I thought I was on the right path. I thought we were well. But now everything has changed. I don't know my way, I want to go back, but there is no going back. Only forward. I don't have the strength to put one foot in front of the other. You carry me in Your arms when I am too weak to walk this path on my own. Trouble may seek to take my life, but she can't take me out of Your arms. The harder she pulls the tighter you pull me in.

I trust in the strength of Your embrace. You are my God. My Father. The one who loves me no matter how hard the path I walk becomes. When the darkness closes around me You light the way. My life is in Your hands. It doesn't matter what the enemy of my soul does. It doesn't matter how loud the voices of doubt scream at me, You hold my entire lifespan in the palm of Your hand. In You I trust.

## Sunrise Reflections

There are seasons that seem all is right with the world. That at last you can rest and enjoy the best life has to offer. Then without

warning everything changes. There really doesn't have to be a reason. Sometimes things just are. We are quick to attach reasons to everything life throws at us—good or bad. But that really just isn't so. Or at least the reason is not always within our grasp. That's where trust comes in. What do you put your trust in? Is it your bank account? Your spouse? Parents? What makes you feel safe in an unsafe and turbulent world? Where does your deepest trust lie?

## Be Still and Know

I am the apple of my creator's eye. Sorrow, sickness, and death have no power over me. I will trust in the grip of my God to keep me in perfect peace no matter what life gives or takes away. Everything is in His hands—including my life. He is my God. He is my salvation to the end of my days. I trust only in Him.

## Day 13: What Am I Waiting For?

I wait for the LORD, my whole being waits, and in his word I put my hope. I wait for the Lord more than watchmen wait for the morning, more than watchmen wait for the morning.

—Psalm 130:5–6

I don't feel You, Lord. Where are You in this dark time? I call Your name, and my prayers feel like they are hitting the ceiling and falling down around my feet. My requests continue to pile and go unanswered. Why can't I feel you right now? Why have you withdrawn Your hand from me? I cannot do this without You. I don't want to be alone. My life feels dry, my joy is just a memory. My whole being waits for Your voice. Silence sweeps over my soul. And still I will wait. I will hold on to the hope You have given me.

Just as I know the morning light will come even though I can't see it I know You are near to me. You have not forgotten me. You will never forsake me. I don't have to feel You to know You are near. I put my hope in Your promises. You never change. You are the same today as You were when I heard Your voice tell me You have me in Your hand. You are near. Your Word never fails. I will wait for You. Here I will sit in the knowledge that Your Word is true. I will bathe in the hope that brings new life. Your goodness and mercies are renewed every morning. As the watchmen of old waited at the gates of the city watching for the morning, so will I wait for You to transform this darkness into light. There is no darkness that can extinguish my hope in You.

## Sunrise Reflections

Have you thought about how much our lives are like the seasons? There are times of rain and sun. Drought and floods. Our spiritual lives are like that too. There are times when it seems as though we are living in a spiritual desert. Your soul is thirsty, but nothing can quench it. Those are the times of waiting. He is not gone. He is near. This is your time to wait for Him. Waiting and trust go hand in hand. In order to wait you have to trust that He will come. Are you waiting for answers to prayers that don't seem to come? Or do you trust that God cares and anchor your hope in that knowledge? What, or who, are you really waiting for?

## Be Still and Know

God knows my heart. He has my tears in a bottle. His love never fails. I will wait on the Lord. Because His timing is perfect. I put my hope and trust in His Word that tells me He will never leave me or forsake me.

# Day 14: Who Am I?

I have loved you with an everlasting love.

—Jeremiah 31:3

Who am I that You would love me? I try to paint on the face that says all is well. But You know better. I try to hide from You. My sins are many. I don't want You to see me for who I really am. I think You will surely reject me when You know the truth. I have lied. I lie to myself most of all. I'm scared. Deep inside I know I am not worthy of Your love. Nothing I can do can change that. Why do You keep calling my name? Why do You pursue me with Your love? Don't You know who I am? I don't even know who I am. But I know who I belong to. I belong to the Creator of heaven and earth.

You made me from dust. I am fragile and weak in spirit. But in my weakness, You are strong. You sought me in the desert and poured Your spirit over me. When I hid, You called me out. You took my garments of shame and wrapped me in Your white robe of grace. You clothe me with Your peace and place a crown of honor on my head. I am Yours. You have loved me from the foundations of the earth. You held me in my mother's womb. You have prepared a place for me to spend eternity with You. You have loved me with an everlasting love that is beyond my ability to understand. You loved me when I was unlovable. When I didn't deserve Your love, You gave it freely. I love You, Lord, because You first loved me.

## Sunrise Reflections

Which do you think is more beautiful—your inside or your outside? Most of us tend to pay quite a bit of attention to our appearance.

While everyone has his or her comfort level, it always lands on what makes us feel acceptable. We strive to be accepted by our spouses, coworkers, or friends. We were created to connect with one another. And yet it's so easy to reject ourselves. The everlasting love of the Father is a love far beyond what we are capable of; it's hard for us to fully understand. So we hide. Are there areas of your life you feel are too ugly for the Lord to love? He's calling you out from your hiding place. He already knows you fully. What will you lay in His hands this morning?

## Be Still and Know

God loves me where I am today. He will never love me more than He does this very minute. Because He has always loved me with an everlasting love that transcends all my iniquities.

# Day 15: The Path with the Most Resistance

Trust in the LORD with all your heart and lean not on your own understanding.

—Proverbs 3:5

Which way do I go, Lord? To the right seems fraught with problems. To the left seems easy, but I don't have peace about it. Nowhere I turn has good answers. My mind and my heart wrestle in my chest. They won't give me peace. I don't know what to do. It seems no matter my choice, it is not good for someone. All I see is more pain, and I can't avoid it. How can I know what is the right way to go? If I follow my heart and do what I believe You would have me do, I am choosing the hardest path.

I trust in You. I know my understanding is limited. My knowledge of this life is but a glimpse of what You see. You, Lord, have my heart and my life. I trust in You. You alone can make a way where there is none. You are the God who parted the sea, so part the seas of indecision. Make my path clear and straight before me. I will put my trust in You. Even though I can't see what tomorrow will bring, You can. I will not weigh my reasonings; I will trust You with all my heart.

## Sunrise Reflections

Is your heart telling you what you need to do but fear keeps creeping alongside it? Fear can't touch you. It can haunt you and rob you of your trust in the God who loves you. Could it be that whatever God is asking you to do, the fear that latches onto it is the equal and opposite reaction of the goodness God has planned for you? What is it you are afraid to do?

## Be Still and Know

I trust in my Lord with all my heart. The same God who parted the sea will make a way for me to be my best self. He is the one who created me and is still creating me. There is no wisdom this world has to offer me that surpasses the love God has for me. All that He is calling me to do is already within my grasp. I don't have to figure everything out myself or make detailed plans. I choose to trust His Word and the assurance He has put in my heart. He will direct me step by step.

# Day 16: Where Does My Strength Come From?

I can do all things through Christ which strengtheneth me.

—Philippians 4:13 KJV

The simplest tasks can overwhelm me. They seem so easy to do, and yet I don't do them. The things I don't want to do come without trouble or resistance. Why am I so weak in spirit, Lord? My strength is almost gone, and yet I hear You say keep going. I pray for Your strength when mine is gone. But Lord, I am running on my own strength most of the time. I want to believe I am strong. I want others to think I am strong. I'm really not, though, am I, Lord? I am Yours. Make Your strength mine.

I don't want to run on my own power anymore. I need Your strength. I need Your strength to walk into the lion's den. I need Your strength to press into the path set before me without wavering, without seeking a way around the fire. Whatever comes to me, whatever my life will hold, I will say, "Blessed is the Lord of hosts, he is my God who strengthens me." You give me strength through Christ; in Him I am a warrior able to snatch the fiery darts of despair the enemy throws at me. You lift me up. I ride on the shoulders of a loving Father in heaven. You dress me in Your strength, not mine.

## Sunrise Reflections

Self-reliance is so ingrained in American culture that we have a hard time even admitting to God we need His strength sometimes.

We run on our own power. When that finally runs out, we ask for help. When we think we have everything under control and can handle it—do we really? We can do *all* things through Christ. Or have we just allowed ourselves to be content with what we can do on our own without Christ?

## Be Still and Know

There is nothing this life can throw at me that I cannot walk through in the power of the Son of God. He strengthens me. My weakness is where He fills me with His strength. I choose not to try to do anything within my own power. All my strength comes from the Lord. My strength to have hard conversations comes from Him. I will not fear. My strength to face the unknown comes from my Lord; I am brave. My strength to love fiercely without fear comes from Jesus who loved me enough to die for me.

## Day 17: I Will Trust the Lord

> But blessed is the one who trusts in the LORD, whose confidence is in him.
>
> —Jeremiah 17:7

Everywhere I look I see those who proclaim they have Your blessings. The beautiful people with flawless skin and perfect smiles tell me their way is the way to happiness—the homes beyond my reach, the travel, the cars, all the shiny things that sparkle with success. Each one claims to hold the key to happiness. And yet I see no happiness there. The fulfillment they offer is fleeting. I need more than they can offer, Lord. I need Your sustaining joy. I need the deep, uplifting joy that can only be found in You.

I am blessed. I am blessed with the knowledge You alone bring happiness, Lord. It is You. I know happiness cannot be bought, sought, or even found in anything on this earth. Happiness is a by-product of walking in Your presence. The joy that comes when You fill my heart when I remember the good things You have done in my life for me. True, abiding happiness always follows. I trust that no matter what I possess or never obtain, in You, Lord, I will be satisfied.

## Sunrise Reflections

*If I can just get through this . . . Once this is over . . . If I can hold on until . . .* are all the false promises we give ourselves. We try to direct our hope to a happiness that is always just beyond our grasp. Happiness is always near. But it is elusive. If you try to

chase it, it will flee from you. If you try to capture it, you will smother it. Happiness is what fills the belly of contentment. Contentment is conceived in trust. When you can trust in the Lord, that everything you now are enduring will work for your good, you will be blessed in all circumstances both now and in the future. What are you waiting to happen, or to pass, before you will trust Him?

## Be Still and Know

The Lord blesses those who are poor in spirit. I will see the kingdom of heaven. My mourning does not separate me from God; it brings Him closer to comfort me. God is near to me when I am weak. I do not have to wait until my circumstances change to feel happiness, contentment, or peace because I trust in the Living God who brings all things to good. Evil will never triumph over me. Circumstances have no power to take my happiness. I am blessed beyond measure because I trust in the Holy One of Israel.

## Day 18:  Choose Joy

Rejoice always, pray continually, give thanks in all circumstances; for this is God's will for you in Christ Jesus. Do not quench the Spirit. . . . hold on to what is good.

—1 Thessalonians 5:16–21

*H*ave I suffocated your Holy Spirit with my anguish, Father? Your voice has become a whisper my spirit strains to hear. I have fed my sorrow a steady diet of doubt and fears. The heaviness of my complaining grows daily. I'm not sure if I can bear its weight. Where is my joy? Have I traded my regrets for Your joy? My moaning against my circumstances has replaced my prayers of thankfulness. I no longer look for your goodness in every situation. Father, with everything that is in me, I will hold on to Your goodness.

I choose Your joy. In all things, I will choose the joy that comes with thanksgiving and praise. My heart will sing of your goodness day and night. When I rise in the morning, I will reach for You. When I lay my head down at night, I will thank You for every good thing the day has brought and lay at Your feet the rest. In every situation, I will look for Your fingerprints. It doesn't matter what it looks like to me. I will never stop praying, my spirit is sustained by Your presence. I belong to You.

## Sunrise Reflections

In Philippians 4:8 we read, "Finally, brothers and sisters, whatever is true, whatever is noble, whatever is right, whatever is pure, whatever is lovely, whatever is admirable—if anything is excellent or praiseworthy—think about such things." Nothing in life happens in a vacuum. Have you ever noticed there is seldom a time

when everything is wonderful? Or everything is horrible? More often than not when everything seems either one way or another it is because it is how you choose to see it. The renewing of the mind means we choose to see good in every situation. When we do, we allow the Holy Spirit to work in our lives. This is how God the Father has equipped you to be an overcomer in every situation. Is there an area or situation of your life in which you have poured more doubts or fear into than prayers? Have you followed the will of God by holding on to what is good today?

## Be Still and Know

I will adhere to the Lord's words. In all things, I will listen for His word to guide me. I will keep His words in the midst of my heart. For they are life. They are my life, health, and happiness. I will not stifle the Holy Spirit. I am called by Christ's name. In all things I will seek what is good, pure, and praiseworthy. Thanksgiving will always be on my lips, in all things and in all circumstances. Because I belong to the Lord Christ Jesus, and in Him I trust.

## Day 19:  Resting in Him

Come to me, all you who are weary and burdened, and I
will give you rest.

—Matthew 11:28

My body can't rest. It has lost all of its strength. Sleep runs
from me. My mind wrestles day and night with fear, regret,
and sorrow. I am weary, Lord. Worry slips into what sleep
I can find and masquerades as nightmares. I don't know what
tomorrow will bring. I fear it will bring more hardship than today.
Yet when I look at today, I don't see the lies I believed yesterday. At
least, not when I look for You. I see Your goodness.

I feel You call me. You bid me come. I will run to the shadow of
Your grace and lay down my sorrow at Your feet. My burdens don't
scare or surprise You. Your rest is new life. It brings me hope in the
midst of sorrow and joy in the throes of circumstances I cannot
change. You care for me in ways I cannot imagine. You don't want
me to try to carry the worries and burdens of my life; instead You
want me to give them to You. Why is that so hard for me to do, Lord?
Take from me that which I cannot change. What I can change, I place
into Your hands to mold in me the image of Your Son.

## Sunrise Reflections

Why do we wrestle so hard with the cares of this life when we are
powerless to change them? Are you trying to change your life with
your own power? Your own limited understanding of the life God
has given you? Is there an area of your life you need to go to Jesus
and allow Him to carry it for you?

## Be Still and Know

The Son of God came that we could have a full life. Our weakness, our weariness, and our sorrows are not ours to carry alone. There is nothing you face, now or in the future, that the living God did not already make a way through for you. It began when He sent His Son to conquer death and wipe away our shame with the forgiveness of our sins. His love is everlasting.

## Day 20: No Room for Worry

Do not be anxious about anything, but in every situation, by prayer and petition, with thanksgiving, present your requests to God.

—Philippians 4:6

My chest is heavy. Thoughts of the unknown haunt me. They taunt me with scenes of my life's destruction. Or worse, the loss and despair of those I love. How long, Lord, do I have to wait for the days of plenty? Where are Your blessings? How long will I have to endure not knowing what my future will hold? I feel as though I am caught in the web of the evil one's lies. I struggle to free myself, but my floundering only binds me tighter. Father, set me free from the entanglements that keep me from You.

Thank You, Lord, for loving me enough to hear my cry. I will remember the goodness You have shown me. The times of trouble when I needed You there, called on Your name, and You answered. I will wait for You because Your timing is never the same as mine. It is perfect. I am not. You care about the health of my body, mind, and spirit. I will bring my needs to You with a thankful heart that You already know and want to fulfill them.

## Sunrise Reflections

How do you approach the God of the universe? Do you speak to Him in formal terms? Do you come to the throne as a child seeking an audience with the King? Scripture tells us the way to come to God is without worry. Do you pour worry into your prayers? When was the last time your Sunrise Reflections were filled with thankfulness?

When we approach the throne of heaven with thanksgiving in the place of worry, we can make our needs known with confidence. More than that, it opens our lives to receive the goodness He has for us. Where can you exchange thankfulness in place of worry?

## Be Still and Know

God knows what I have need of. I am thankful for all He has given me. His mercies have given me hope for a new life. His peace has filled the empty spaces in my heart. He has broken the chains of death and snapped the back of fear. I will not be afraid. Anxiety has no place in me. He fills my heart with an everlasting love and casts out all my fears. I bring my requests to Him in the full knowledge that, in His time, He will not just take care of me but will pour out His goodness upon me.

## Day 21: The Author

And we know that in all things God works for the good of those who love him, who have been called according to his purpose.

—Romans 8:28

I see no good coming from this sorrow I endure. How can good come from evil? How does good come from death, sickness, or addictions? There is nothing good in this pain I feel. The hands of time just keep going and refuse to stop. I would stop time if I could and go back to the last day my life was whole and right. I miss the joy I found there. The joy I had in the goodness You poured over me.

And yet I know these are not the circumstances You created. They are the consequences of a fallen world. One that has denied You and gone its own way. You hear my cries. You hold my tears. Although I cannot see one single good thing to wring out of these circumstances that would equal the cost, I will praise You. My love for You will not waver. My trust in You is as deep as my hurt. Your ways are not my ways. Your ways are higher than mine. You care not only for my circumstances but beyond into eternity. Therefore I trust that You will bring forth good out of what the enemy of my soul sought to destroy.

## Sunrise Reflections

Silver linings don't come after every storm. But new life does. Where we cannot see the good in what has come into our lives is where we have to plant seeds of trust. Our assurance comes from knowing His Word is true and He has not allowed this pain to destroy us. In everything, we can give thanks in knowing the story is not over.

Imagine yourself the superhero in the middle of a movie—maybe hanging off the cliff by one hand or free falling to what looks like certain death. The Author of life, your life, has the end in mind. This is not the end. Where are You in the story God is writing?

## Be Still and Know

I am called by God's purpose. It doesn't matter what my circumstances tell me. I know He is the author and finisher of my faith—and my life. Where all looks bad, He who made the stars from the words of His mouth can bring goodness. I am not the author of my story, the Father is. But He made me the hero, just as He did to a shepherd boy named David and a slave named Moses.

**If you enjoyed this book, will you consider sharing the message with others?**

Let us know your thoughts at info@newhopepublishers.com. You can also let the author know by visiting or sharing a photo of the cover on our social media pages or leaving a review at a retailer's site. All of it helps us get the message out!

Twitter.com/NewHopeBooks
Facebook.com/NewHopePublishers
Instagram.com/NewHopePublishers

---

New Hope® Publishers is an imprint of Iron Stream Media, which derives its name from Proverbs 27:17,

"As iron sharpens iron, so one person sharpens another."

This sharpening describes the process of discipleship, one to another. With this in mind, Iron Stream Media provides a variety of solutions for churches, missionaries, and nonprofits ranging from in-depth Bible study curriculum and Christian book publishing to custom publishing and consultative services. Through the popular Life Bible Study and Student Life Bible Study brands, ISM provides web-based full-year and short-term Bible study teaching plans as well as printed devotionals, Bibles, and discipleship curriculum.

For more information on ISM and
New Hope Publishers, please visit

IronStreamMedia.com
NewHopePublishers.com

# GOD CAN HANDLE YOUR QUESTIONS, DOUBTS, AND FEARS.

Available from NewHopePublishers.com
and your favorite retailer.

# YOU MAY ALSO ENJOY . . .

*BEAUTIFUL WARRIOR* EMPOWERS YOU TO BREAK FREE FROM THE INSECURITY THAT HAS YOU TRAPPED.

Printed in the United States
By Bookmasters